IMAGES
of America

SAM'S CASTLE

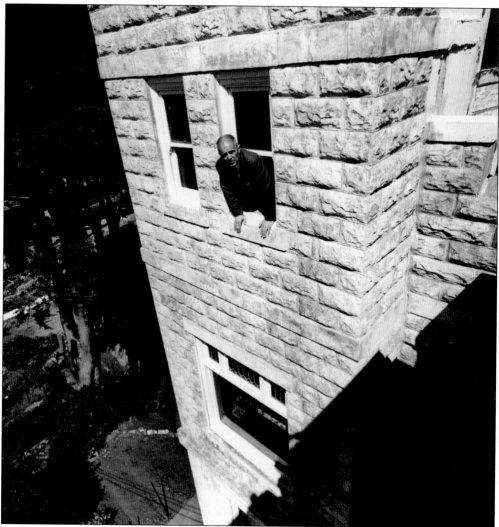

Sam Mazza was a unique character who took great pleasure in sharing his stately home with local groups, friends, and high-powered politicians. With his trademark humor and impeccable style, the Italian-born painting contractor turned the mansion into a showcase of his fine collectables without taking itself too seriously. He flew a "Sam's White Elephant" flag from the roof and added whimsical white balls to the top of each turret—only those balls were actually toilet floats he had had painted white. He loved telling people that. Mazza bought the castle to have fun, and that's just what he did—from hosting elegant parties to welcoming previous residents who stopped by with great stories. When he passed away peacefully at age 96, it was his wish that people would continue to enjoy the grand castle as he had. Keep an eye out for tours so as not to miss a look inside this treasured landmark of Pacifica's colorful past. (Sam Mazza Foundation.)

ON THE COVER: Sam's Castle, lined by Milagra Ridge, stands majestically overlooking Pacifica's Sharp Park. If this is one's first introduction to the castle, look up the hill just when passing the Paloma Avenue/Francisco Boulevard exit (while heading south on Highway 1), and it can be seen in all its turreted splendor. (Sam Mazza Foundation.)

IMAGES
of *America*

SAM'S CASTLE

Bridget Oates

ARCADIA
PUBLISHING

Published by Arcadia Publishing
Charleston, South Carolina

Printed in the United States of America

Library of Congress Control Number: 2010939831

For all general information, please contact Arcadia Publishing:
Telephone 843-853-2070
Fax 843-853-0044
E-mail sales@arcadiapublishing.com
For customer service and orders:
Toll-Free 1-888-313-2665

Visit us on the Internet at www.arcadiapublishing.com

This book is dedicated to my grandmother Hazel.

CONTENTS

ACKNOWLEDGMENTS

Writing this book brought so many fantastic people into my life, and for that I am deeply grateful. For all of you who welcomed me into your homes and archives to let me rifle through your precious photographs with incessant questions, I thank you! I could not have written this book without your patience, time, and generosity. I would first like to thank Jeanette Cool of the Sam Mazza Foundation for opening the castle doors to me; Pete McCloskey for sharing his fascinating life stories and photographs (and all during the PGA Tour!); and his sister Virginia (McCloskey) Hartzell for her lightning-fast responses and fantastic images. Special thanks to my editor, John Poultney, for his support and guidance and to Bob Azzaro for generously providing so many fabulous photographs, as well as for his patience answering my endless structural questions. I bow down to Marco Garcia's enduring positivity, his willingness to share his precious weekend time and his Photoshop brilliance. Other image angels are Cody Williams at Rayko, Jason Mazza, Joe O'Brien, Joan Whitney McLain, Elaine Larsen of the *Pacifica Tribune*, Kathleen Manning and Jerry Crow of the Pacifica Historical Society, Melinda Lindner, Matt Korn of June Morrall's estate, David Rosen and Scott Price of the US Coast Guard, Deb and Michael Wong (www.springmountaingallery.com), Jim Coen, and Jon Sullberg.

For those who provided invaluable information or led me to the source, I thank Captain Realyvasquez of the Pacifica police department, Rick Bennett at Salada Beach Café, Lydia Guzman, Monty Montgomery and all the reference librarians at the California State Archives, and the San Mateo, Pacifica, San Francisco, and University of California Berkeley libraries. Lastly, very special, heartfelt thanks go to all of my friends and family who cheered me on: Ann Bleakley and Steve Watson, I can't thank you enough for your daily humor and unwavering support; Sheila Lichtblau for the legal read; Larry Hess, Gina Moore, Mollie Jensen, Natalie Quinan, Laetitia Mailhes, Tricia Choi, Julie Oxendale, and Derek Bobbe for encouraging me to take breaks; and Gillian Briley, Lauralee Roark, Carol Normandi, Michael and Margie Oates, Mom, Dad, Gail North, and all my cousins, aunts, and uncles.

INTRODUCTION

Ever since the castle was built in Salada Beach (now Pacifica's Sharp Park), it has been known as the McCloskey Castle, Castle of Mystery, Chateau LaFayette, and for the last 50 years, Sam's Castle. Sam Mazza purchased the "pile of bricks" (as he liked to call it) in 1959 for a cool $29,000 and brought it back from severe disrepair, leaving an elegant, museum-like landmark of Pacifica's colorful past. Now in the hands of the Sam Mazza Foundation, the castle will host fundraisers supporting charitable causes, as well as occasional tours and other events, just as Mazza wanted. Once thought to be haunted, with bodies buried on the castle grounds, the mysterious castle has thrilled, frightened, and intrigued people for over a century—for good reason.

Henry Harrison McCloskey, grandfather to former congressman Pete McCloskey, had the castle built in 1908 after he witnessed the devastation and widespread destruction of the 1906 earthquake. There were just a few buildings in the sleepy farming community when the McCloskey fortress went up on the hill. The majority of those structures were built by Mathius (Math) Anderson, who is an important part of the castle history for two reasons: his remarkable redwood interior remains to be admired today, and he is one half of the first castle love story. Anderson met Bertha Johnson in the castle kitchen, and after a seven-month courtship tooling around in his car—the only one in the county—they celebrated their wedding reception at the castle in July 1916.

Henry Harrison McCloskey could not have imagined his grand mansion would become the site of police raids and the source of screaming newspaper headlines. However, once the second owner, Galen R. Hickok, was discovered performing abortions there in 1916, that is exactly what happened. An insidious rumor soon surfaced that the doctor had buried bodies from his botched operations in the garden, prompting police to arrive at the castle with shovels in hand. Amazingly, they did indeed dig up bones—chicken bones. The doctor was arrested and sent to San Quentin for five years, but trouble wasn't over for the local sheriff. Prohibition brought more police to the castle between 1922 and 1924, but this time they didn't bring shovels—they arrived with battering rams and sledgehammers after speakeasy owner M.L. Hewitt barred the front door. Hewitt transformed the castle into Chateau LaFayette, with dining and dancing overlooking the ocean, and he blatantly ignored the anti-liquor laws, but then so did many bar owners in Salada Beach. The dense fog and unforgiving roads made it exceptionally difficult to police the area, and it became a haven for rumrunners. Hewitt signaled the liquor-laden ships from the castle and went right on serving his guests until his death in 1924.

The castle changed hands three more times and then settled into a healthy respite while it was in the hands of the Eakin family. However, in 1942, the castle underwent another calamitous year when the Eakins rented their stately home to the Coast Guard's Beach Patrol during World War II. Lieutenant Carr and 13 servicemen who made up Company H moved in on November 18, 1942. Their vicious war dogs did not get the luxury of living at the castle; they bunked next door in kennels. The floors installed by master craftsman Math Anderson got a thorough polishing whenever the men were caught disobeying orders, such as patrolling together. The accommodations were tight for that many servicemen, and the castle took a beating during the year they were there. The Coast Guard offered the Eakins a settlement, but soon after, Mr. Eakin died and the repairs were not completed. Annie Eakin is rumored to have filled the castle with as

many as 20 cats after her husband passed away and her adopted son Charles was institutionalized. After Annie passed away, an artist couple and their children took up residence in the reportedly haunted house on the hill for five years. Pat O'Brien was a sculptor trained under the famous Gutzon Borglum, who was made famous by his work on Mount Rushmore. He left his enduring mark on the castle with a submarine portal in the front door. The castle never fully recovered its original grandeur until Sam Mazza, a painting contractor with an eye for white elephants, saw the diamond in the rough.

When Mazza first acquired the castle, the garden was overgrown with four-foot-tall weeds, and local kids who believed it to be haunted had ravaged it. The young vandals broke windows while hunting for the paranormal visitors, so Sam did what he knew best. He threw a party and invited the local kids, who never returned to the castle uninvited again. Italian-born Mazza brought the castle back from ruin and gave it a touch of class and whimsy.

Sam Mazza and his wife, Mary, never lived in the castle, but they loved entertaining there. For over five decades, Sam and Mary hosted countless friends, beauty queens, pageant hopefuls, and politicians on their way up or celebrating victory. One of the Mazzas' most notable parties was held for Henry Harrison McCloskey's grandson, Pete McCloskey, after his election to Congress in 1967. At the momentous occasion, Pete's father, Paul McCloskey, was finally able to show his son around the house his grandfather built for the McCloskey family 59 years earlier. Pete, coined the first maverick, went on to make a run for the presidency, but he never forgot where his family came from.

Before Sam Mazza passed away peacefully at 96 years of age, he ensured that the castle would continue to thrive in the hands of the Sam Mazza Foundation. The intriguing historical mansion, often considered one of the Bay Area's architectural treasures, will continue to entertain charitable organizations, ghost hunters, history buffs, and those who just want to drink in the majestic view for themselves. Find out more about the castle at www.sammazzafoundation.com, or look up the tour schedule at pacificahistory.org.

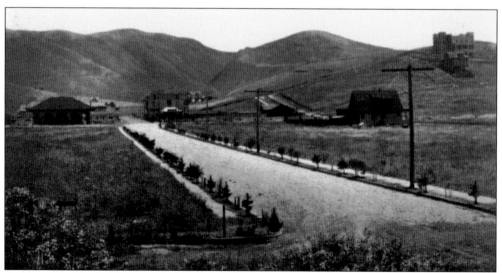

Real estate developers created postcards like this to show off the Salada Beach area. It reads, "All the delights of country life with every city advantage." At that time, the "delights" consisted of the Little Brown Church (right), Salada Mercantile (center), the castle on the hill, and a few scattered homes. (Scott and Melinda Lindner.)

One

THE MCCLOSKEYS
1908–1916

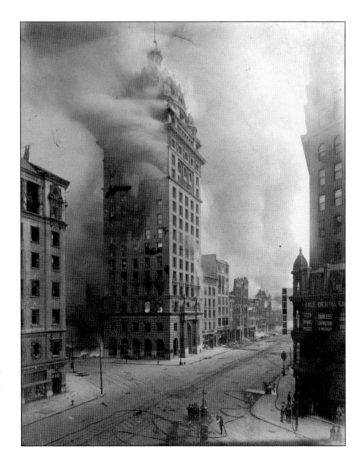

On April 18, 1906, the largest earthquake in North American history struck at 5:12 a.m. Though it lasted less than one minute, fires ravaged San Francisco for four days and displaced over 250,000 people. Deeply affected by the widespread devastation, Henry Harrison McCloskey decided to create a fortress that would never burn or fall, and that is how Pacifica's grand castle came to be. (Jim Coen.)

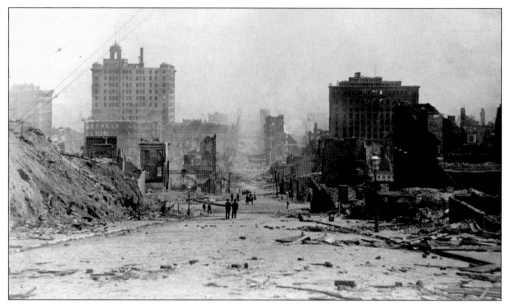

Henry McCloskey's law office in the prestigious Merchants Exchange Building (on right) was completely gutted in the post-quake fire. His client, the Ocean Shore Land Company, however, provided a bright spark of hope for the future. With interests in Salada Beach, they believed that the small country town was ripe for development and could become a booming tourist haven. (Private collection.)

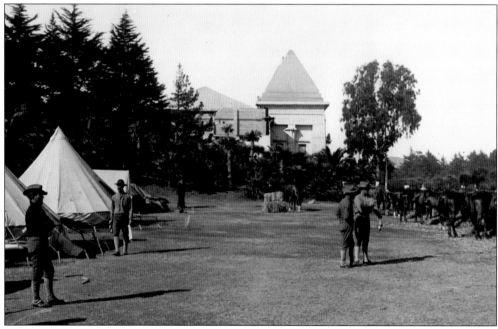

Sold on his client's future vision, Henry McCloskey formulated his plan while the family camped out alongside their neighbors for fear of aftershocks. There were refugee camps all across the city, and the US Army, shown here in Golden Gate Park, kept the peace. Though their Sixth Avenue home was intact, minus the chimney, McCloskey was determined to move his family out of the city as quickly as possible. (Private collection.)

Henry McCloskey first came to Salada Beach by horse and buggy, and he chose a spot high on the hill for his unshakeable stronghold. There were many who contributed to the building effort of the 24-room castle, but one man in particular, Mathius "Math" Anderson, left an enduring legacy with his woodworking craftsmanship. For more intricate details on how the castle was built, see chapter seven. (Jon Sullberg, *Unknown Pacifica*.)

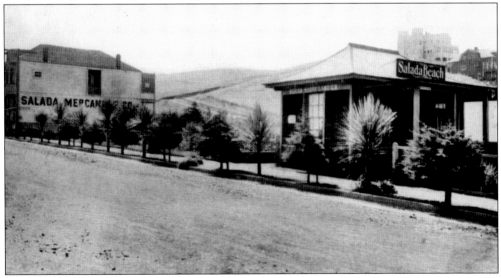

Math Anderson was an accomplished carpenter who built his own business, Salada Mercantile, just down the hill from the castle. His market kept the town stocked with supplies, and it would one day lead the love of his life right into his own backyard—the castle kitchen. But it would be a few more years before that happened. (Jim Coen.)

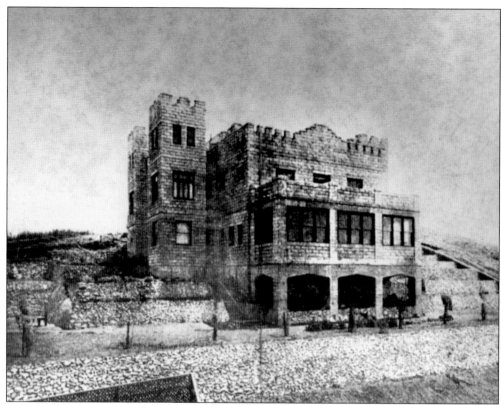

Henry and Emily McCloskey moved into the castle with their daughters, Marion and Laura, and their son, Paul, before it was completely finished. One of their daughters had consumption, and doctors thought the sea air would help her heal. During construction, the McCloskeys were one of only 12 families living in San Carlos. It must have been quite a commute to Henry McCloskey's new office in the penthouse of the Crocker Building in downtown San Francisco. (Pacifica Historical Society.)

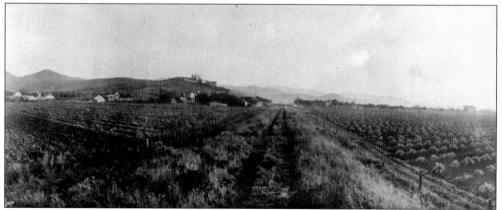

When Math Anderson and the McCloskeys first moved to Salada Beach in the early 1900s, the town was largely made up of artichoke farms and little else, as seen here. Artichokes were in high demand as distributors could pay the local farmers 5.5¢ per artichoke and sell them in New York for 75¢ each. (*Pacifica Tribune* photograph.)

Here is the queen of the castle, Emily (Purinton) McCloskey, enjoying the garden with the family dog. Henry McCloskey spared no expense in creating their dream home, and John McLaren, famous head gardener of Golden Gate Park, reportedly landscaped the grounds. (Virginia McCloskey Hartzell.)

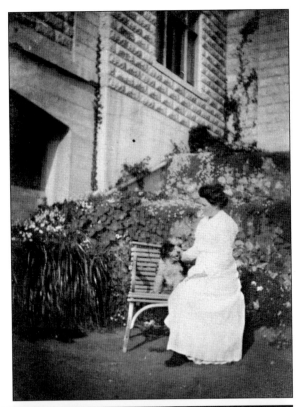

Paul McCloskey was an avid baseball fan, and he often practiced in Golden Gate Park when the family lived next to it on Sixth Avenue. He is pictured here (far right, first row) with his Lowell High School teammates around 1908. After baseball practice, Paul would catch the Ocean Shore Railroad's *Half Moon Bay Express* train at 5:45 p.m. and make it home in just about an hour. (Virginia McCloskey Hartzell.)

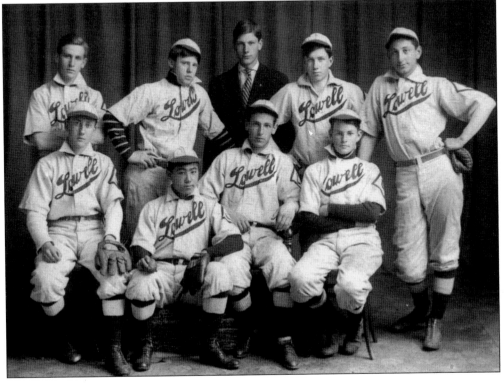

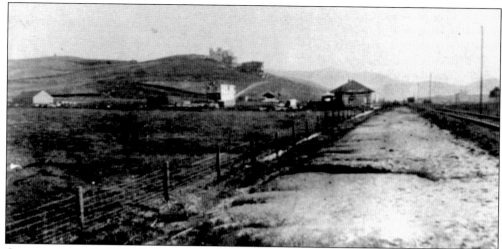

One can picture Paul McCloskey running down the hill with his book bag to catch the morning train, seen here approaching in the distance. Since his bedroom was an unheated turret room, it was probably the best way to warm up on foggy mornings. When the tracks were not washed out, the Ocean Shore Railroad would take Paul to the San Francisco depot at Twelfth and Mission Streets. (Pacifica Historical Society.)

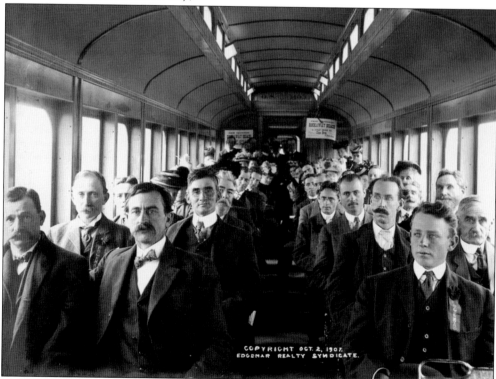

Distinguished gentlemen packed the train on the daily ride to San Francisco. These were probably among the first commuters and no doubt a familiar sight to Paul McCloskey every morning. Henry McCloskey's developer clients at the Ocean Shore Land Company worked tirelessly to convince city folks that Salada Beach would soon be a thriving community, thanks to the railroad. (Pacifica Historical Society.)

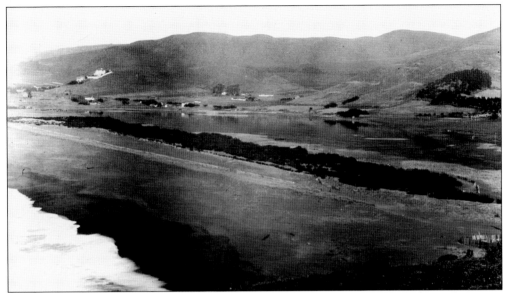

The Spanish originally named Salada Beach *Laguna Salada* for the lagoon shown here, which is now the Sharp Park Golf Course. When the tide was high, the saltwater would spill into the shallow body of water, thus lending it the name "Salty Lagoon." As development got underway, cement pillars were built in the center of the lagoon for a dance pavilion. (Private collection.)

Real estate developers touted the prized homes of Salada Beach on postcards such as this; notice the castle in the middle and on the right. Eager for buyers, developers would drive people down on the weekends and show them around. Prospective home owners were treated to free rides on the railway, picnics, and open-air concerts. Lots started at $250 for a 25-by-50-foot parcel with $10 down and a payment of $3 per month. (Pacifica Historical Society.)

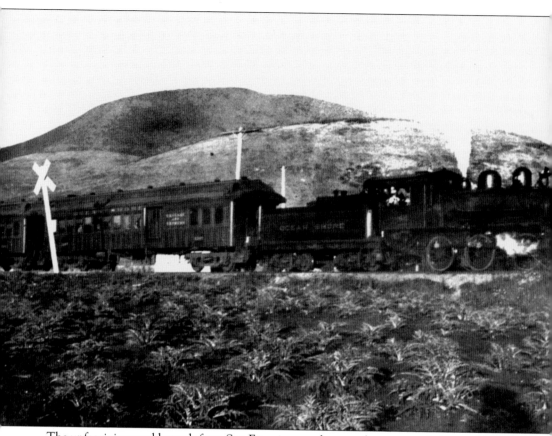

The unforgiving muddy roads from San Francisco made coastal access nearly impossible for most, but the Ocean Shore Railroad changed all that with stops in Salada Beach, Brighton, Edgemar, Rockaway, and Tobin. There were even plans to extend the tracks down to Santa Cruz. Developers tantalized locals with their big plans for casinos, a bandstand, cafés, and a promenade alongside the waves. Homes sprung up mere feet from the water in idyllic Shelter Cove, and many more hillside homes were planned. However, everything hinged on whether the railroad could stabilize and remain a dependable mode of transportation for commuters. (Pacifica Historical Society.)

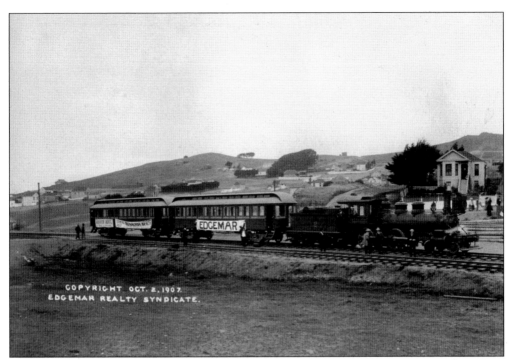

Unfortunately for many commuters, however, washouts that left the tracks dangling were all too common. For the journey home from San Francisco, Paul McCloskey could only hope that this Edgemar-bound train was running. When the tracks were out, Paul would catch a ride on the Southern Pacific and then transfer to a horse and buggy ride for the bumpy, muddy trek down Hog Ranch Road into Salada Beach. Looking closely below, one can see the horse and buggy walking alongside the tracks in Edgemar. (Both, Pacifica Historical Society.)

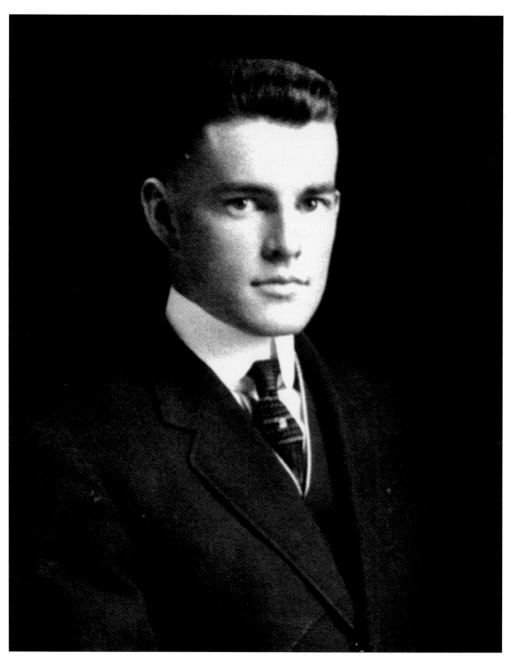

After graduating from Lowell High, Paul McCloskey decided to pursue a career in law like his father. Henry McCloskey's hard work and subsequent success made a big impression on his young son. Paul recalled in his memoirs how his father would return home very late to their Sunset District home, especially while studying for the Bar Exam at Hastings Law School. Henry represented top-notch clients like the Stauffer Chemical Company, A. Schilling & Company, Leslie Salt Company, and the Ocean Shore Land Company, which was the real estate subsidiary of the Ocean Shore Railway Company. Henry must have been very proud when Paul entered Stanford Law School in 1911, though due to an illness, he would not live to see his son graduate. (Virginia McCloskey Hartzell.)

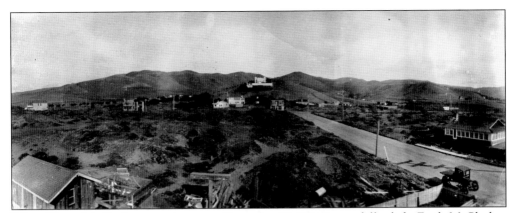

When Henry McCloskey passed away on December 26, 1914, it was difficult for Emily McCloskey to maintain the mortgage. In using the best of everything to build their idyllic castle home, Henry had gone deeply into debt, and keeping the property going drained his pockets even further. Paul, however, was one year away from graduating from Stanford, so Emily managed to keep things going a little longer. (Pacifica Historical Society.)

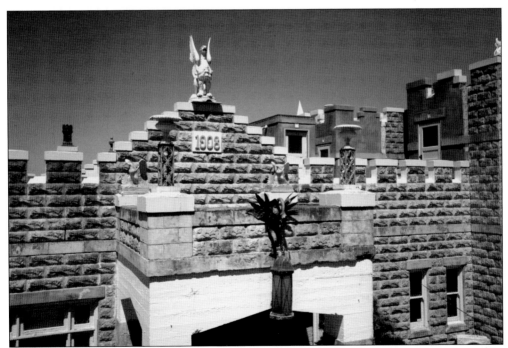

After Paul graduated, Emily traded their home for a 40-acre dairy farm in Buttonwillow owned by Dr. Galen R. Hickok and his wife. As Paul closed the castle gate in 1916, he most likely thought he would never return. Little did he know that 52 years later, he would come back to his castle home to celebrate his son Paul "Pete" McCloskey's election to Congress. (Robert Azzaro.)

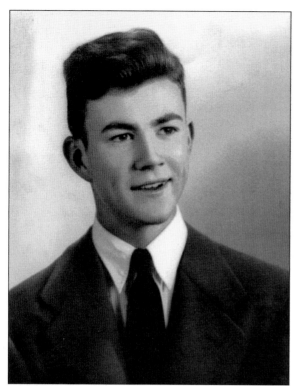

Over the years, Pete McCloskey's notoriety as a congressman has drawn much favored attention to the castle. While it took a few years after this high school portrait as snapped for him to arrive at the White House, a tour of duty in Korea helped him get there. He entered Stanford Law School like his father after high school, but the Korean War delayed his studies. (Virginia McCloskey Hartzell.)

While serving as a marine in Korea, Pete McCloskey (second row, center) made friends with a fellow rifle platoon leader named Chuck Daly. When both men were wounded on the same day and sent home, Pete couldn't have imagined the impact this friendship would soon have on his career. Pete returned from Korea a hero with the Navy Cross, a Silver Star, and two Purple Heart medals. (Pete McCloskey.)

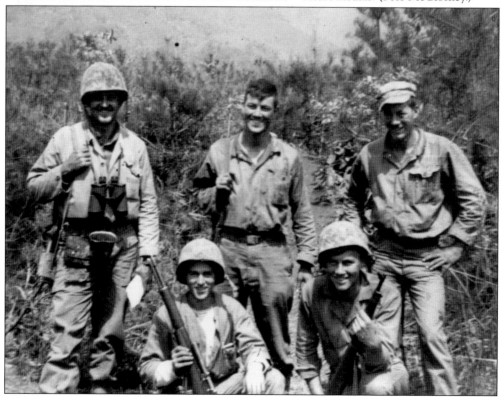

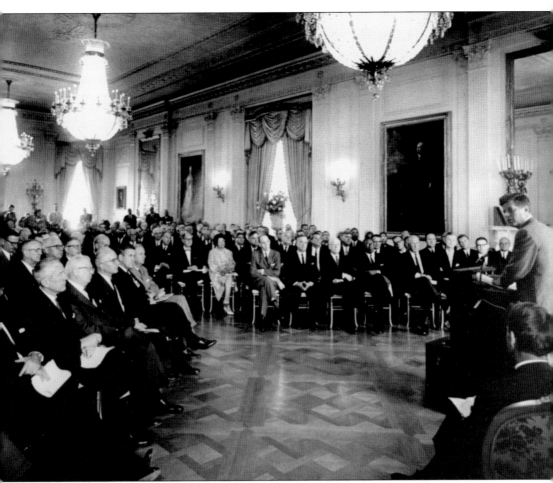

Pete McCloskey was working as an attorney in Woodside when, one day, a telegram arrived from the president of the United States inviting him to the White House. It turns out Pete's friend Chuck Daly was now working in the White House, and they needed more Republican attorneys for an upcoming civil rights conference. After the Birmingham riots, President Kennedy developed a plan to give African Americans access to the white power structure by integrating more African American attorneys in law firms across the country. After the conference, Pete and his firm found an attorney working from the back room of a barbershop in Palo Alto, and they welcomed him into their firm. While sitting before President Kennedy, the course of Pete's career changed, and he decided to enter the political arena. (Pete McCloskey.)

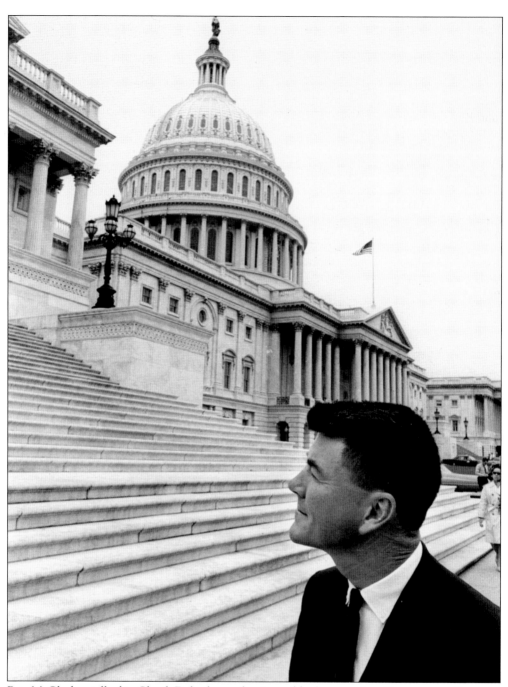

Pete McCloskey talked to Chuck Daly about what it would take to get into Congress, and he went to work. In 1967, he got his chance when Congressman Jay Arthur Younger passed away and a special election was held. Pete entered the running against 11 candidates, including former child movie star Shirley Temple Black. Hoping to win over Pacifica, where his family roots were, Pete and his father went door to door handing out brochures and talking at length with the locals. Pete prevailed in the election and was the first Republican congressman ever to win in San Mateo County. A big celebration was in order. (Pete McCloskey.)

What better place to celebrate Pete McCloskey's election to Congress than the grand castle his grandfather had built? Pete (left) and his father (right) were welcomed by Sam Mazza in 1967 for the memorable evening. Though this was Pete's first visit to his father's childhood home, he returned many times to share his family's history with Pacifica locals. (*Pacifica Tribune* photograph.)

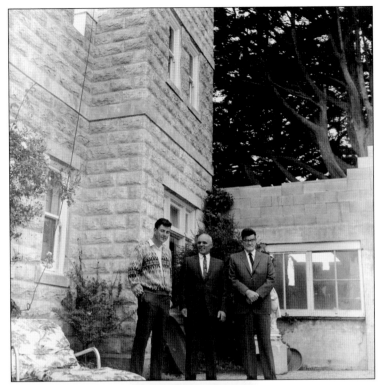

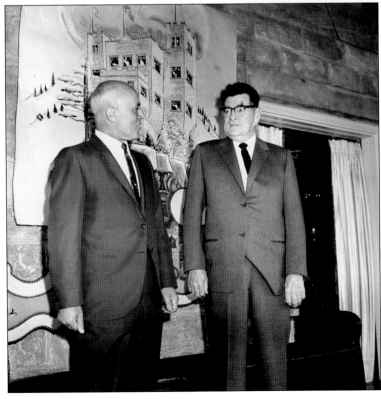

What a surreal experience it must have been for Paul McCloskey to walk through the front door he had exited 52 years earlier with his mother (though it would have to be a different door since the police took a sledgehammer to the old one during the last Chateau LaFayette raid). It is likely there were more changes than Paul, pictured at right with Sam Mazza, could begin to fathom. (*Pacifica Tribune* photograph.)

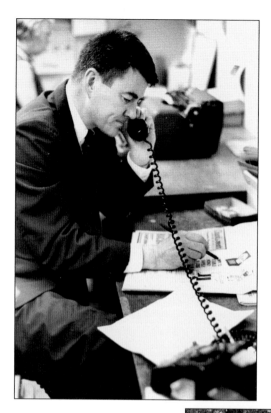

When Pete McCloskey was elected to Congress, the popular vote was two to one in favor of the Vietnam War. Pete was vehemently opposed to the war but still managed to garner the votes, and he was reelected eight more times to represent California's 11th District in Congress from 1967 to 1983. (Since his first term was a special election, he had to run again the following year.) (*Pacifica Tribune* photograph.)

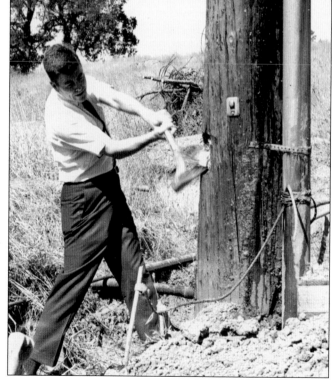

One of the first environmental lawyers in the nation, Pete McCloskey is shown chopping down the last power pole in Woodside in October 1969. The overhead power lines were replaced with tidier ones behind Town Center. Pete also won the battle against the Atomic Energy Commission and utility companies to prevent massive power structures from being put in to run the Stanford Linear Accelerator. (Pete McCloskey.)

was it Lyndon Johnson or Satchel Paige who said, 'Don't look back; they may be gaining on you'?

In 1972, Pete McCloskey returned from his third trip to Vietnam, and he tried to talk three other Republican congressmen into running against Nixon in an effort to put an end to the war. When they weren't game, he entered the race. Though he only got 20 percent of the vote, he stayed the course dictated by his moral compass, despite the political climate. (Pete McCloskey.)

Pete McCloskey never stopped calling for an end to the Vietnam War, and he is shown here passionately arguing his case. "I was so mad there," Pete remembers. In 1973, Pete took his case a step further and made an impeachment speech against Nixon. He stood largely alone in his convictions until the House Committee started their own proceedings against Nixon in July 1974. (Pete McCloskey.)

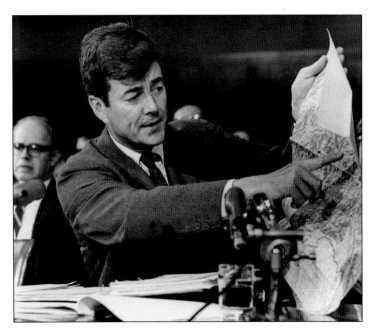

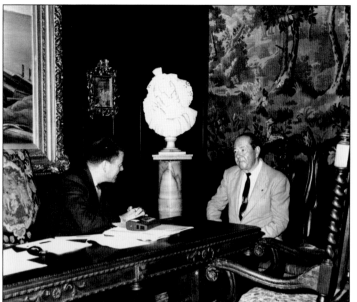

On one of his many visits to the castle, Pete (left) sits at Sam Mazza's grand Louis XVI–style desk, befitting a congressman. The beautifully carved mahogany bureau plat fitted with ormolu trim is one of two in Mazza's impressive collection. (The other can be seen on page 95.) (*Pacifica Tribune* photograph.)

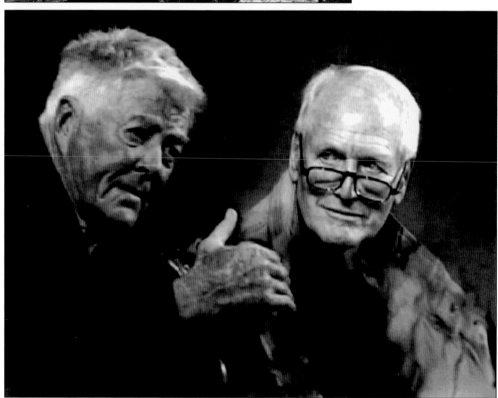

In 2009, Paul Newman (right) narrated a documentary called *Pete McCloskey: Leading from the Front* detailing Pete McCloskey's incredible career. Coined as the original maverick, McCloskey's relentless spirit mimics that of his grandfather, who carved out a permanent place for his family in Pacifica history. Another man who left an enduring mark on Salada Beach, but with a much darker tale, is Dr. Galen R. Hickok. (Pete McCloskey.)

Two

CASTLE OF MYSTERY
1916–1920

Once the shady Dr. Galen R. Hickok took ownership in 1916, things took a sinister turn at the castle. The steady stream of car lights on the forbidding hill under the shroud of darkness drew the watchful eye of Salada Beach's deputy sheriff, E.J. Hutley, and he was right to be suspicious. But before that, it is time for that love story. (Robert Azzaro.)

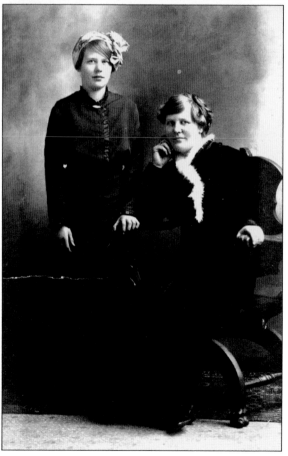

Math Anderson's market was right down the hill from the castle, which made him a natural choice to deliver groceries to the new cook hired by the Hickoks. During the long year Anderson had labored over the interior of the hilltop home, he probably never dreamed he would meet the love of his life there, let alone have his wedding reception in the rooms he built. (Jim Coen.)

Bertha Johnson (right) wasn't so sure about life in the country when she took her first muddy, winding car ride to Salada Beach with Dr. Hickok and his wife. Though the castle was "very nice inside," she recalled in her memoir, "I sure didn't think I was going to stay down here very long." (Jim Coen.)

Bertha Johnson settled in and took over the large kitchen in the castle. Not long after, the handsome owner of Salada Mercantile started showing up with grocery deliveries. Math Anderson was born in Norway, and he had made his way to America on his own at age 16. Bertha was from neighboring Sweden. The two got to talking, and a romance started brewing. (Robert Azzaro.)

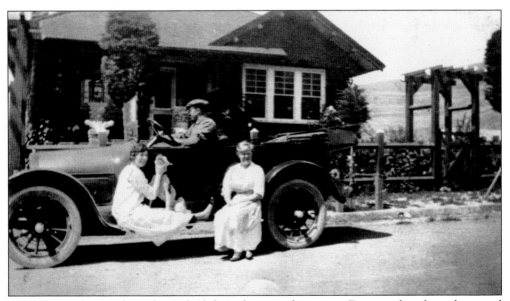

It didn't hurt that Math Anderson had the only car in the county. Everyone loved to ride around with him, or even just lounge on the sideboard of his car. Here Bertha Johnson (right) sits with Eileen Casteel in front of the Casteel house, which was right across the street from Salada Mercantile. (Jim Coen.)

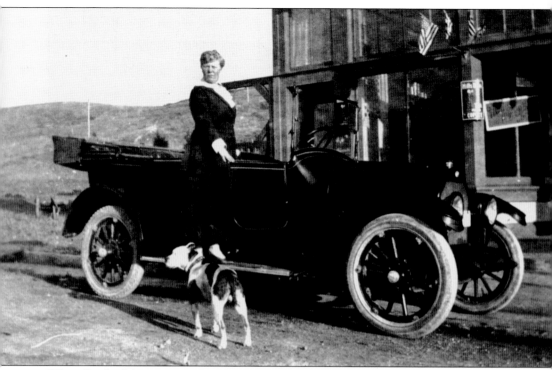

When Bertha Johnson moved to America in 1908, she lived with her sister in Seattle. She was drawn to San Francisco during the Panama-Pacific International Exposition in 1915 and decided to stay. While hunting around for work, an agency recommended the Hickok job to her, with the caveat that it was in the country. She liked going out in San Francisco, but slides would often derail the train, sometimes for months. Math Anderson was more than happy to take her out, which cemented their whirlwind courtship. (Jim Coen.)

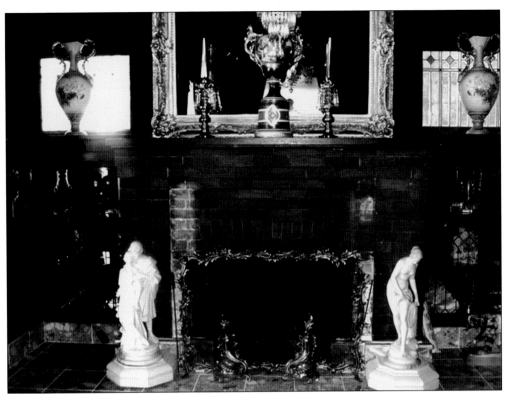

Seven months after they met, Bertha Johnson and Math Anderson married in San Francisco in July 1916. They had their wedding reception at the castle, and Bertha remembered, "Everybody came from all around." Though she added there weren't many people in Salada Beach at the time, they enjoyed dancing in the living room by the fireplace until the early morning hours with the McDonalds, Flemings, and Hutleys, among others. (Bridget Oates.)

Bertha Anderson moved down the hill to the market her husband had built and luckily missed the storm of controversy that erupted at the castle just a few years later. Little Salada Beach would soon be splashed across the headlines, and throngs of reporters would be lining up in the store to phone in their gruesome, often far-fetched, tales. (Jim Coen.)

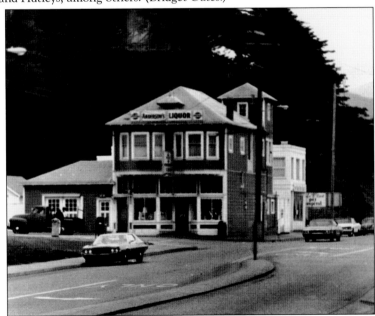

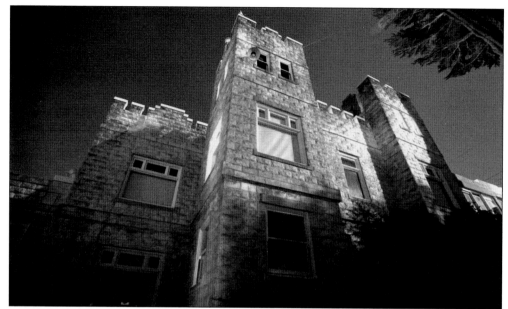

In late August 1920, police received an alarming call from a husband reporting his 21-year-old wife missing. He told them she was last seen in the care of Dr. Hickok at the Salada Beach castle, a retreat for girls and women unwilling to become mothers. The couple unwittingly blew the lid off the doctor's abortion clinic, and as the word spread, the gruesome rumors grew. (Robert Azzaro.)

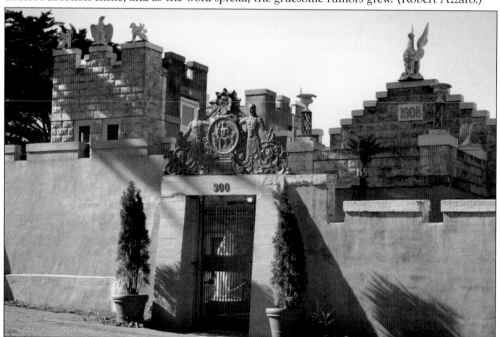

The rumors reached the sheriff, and he sent two detectives to investigate. San Francisco detective sergeant Miles Jackson and policewoman Kate O'Connor arrived to find nurse Cleo Tevis and three recuperating girls, aged 14, 18, and 21. The nurse told officers that the castle was strictly used for convalescing and that no operations were performed there, yet the detectives saw that the rooms were outfitted for surgical procedures. (Robert Azzaro.)

The three patients, Mary Cozzo, Irene Carpenter, and Bertha Casteel, confessed to officer O'Connor that they had indeed received treatment there by Dr. Hickok. Nurse Cleo Tevis (shown here in a courtroom caricature printed in *Other Times*) was promptly arrested, and Dr. Hickok was next on their list—if they could find him. (Sam Mazza Foundation.)

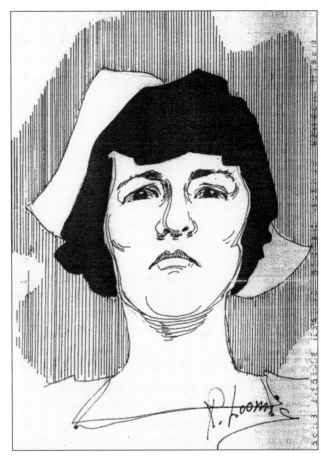

Berkeley police officer Henry O. Hoar arrived at Dr. Hickok's Berkeley home and was told by a servant that the doctor was in San Francisco. Only the servant was actually Hickok. Even after Hoar returned and arrested him, Hickok maintained that they had the wrong man. Hoar turned him over to Berkeley police officer James S. Rooney for the long ferry ride across the San Francisco Bay. (Private collection.)

As they neared the docks and Hickok found out detective sergeant Miles Jackson would be collecting him, he asked officer Rooney to put in a good word for him. He added that he had lots of money and might be able help Rooney out of a hole sometime. Rooney declined his offer and handed him over to Jackson, who remarked, "Well, Doctor, you're back at your old tricks again." (Private collection.)

According to court records, Dr. Hickok pulled Jackson aside as they arrived at the Hall of Justice, saying, "You know it costs a lot of money to hire lawyers, and we might as well keep the money between ourselves." Jackson replied, "Doctor, forget about that kind of talk; nothing doing." The doctor begged him to be easy with him, and the sergeant answered, "I will treat you fair, Doctor, absolutely fair." (Private collection.)

Though the doctor was in custody, the rumors continued to grow, whipping the media into a frenzy. People whispered that the doctor had locked his female patients in the turret rooms when they became gravely ill. Worse yet, if they died, he would bury them in the garden. (Robert Azzaro.)

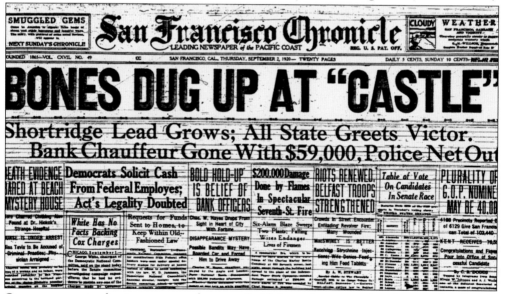

One eager reporter hoping to scoop the story decided to take matters into his own hands, and he sneaked onto the castle grounds to search for proof. After poking around in the garden, he did, amazingly, uncover bones and articles of women's clothing. He rushed down the hill to the nearest telephone to break the story to his editor. Luckily for the intrepid reporter, the Andersons had installed the first telephone (complete with a switchboard) in Salada Beach. (Sam Mazza Foundation.)

THE PACIFIC TELEPHONE AND TELEGRAPH COMPANY
AGENT'S CONTRACT

HEREBY AGREE to act as Agent for THE PACIFIC TELEPHONE AND TELEGRAPH COMPANY

Salada Beach , County of San Mateo , State of California

period of One years, ending June 30th, 1918. and

ter until written notice of terminating this agreement is given by either party thereto, and to furnish the operating,

ght and heat necessary for the proper conduct of the telephone and telegraph business at Salada Beach

make monthly reports and remittances as required by said Company, on or before the 10th day of each month, and if

bers are connected with said office, to collect and remit the rentals of their telephones.

n consideration of the foregoing. THE PACIFIC TELEPHONE AND TELEGRAPH COMPANY agrees to pay

teen - (15) per cen

tolls paid at Salada Beach , exclusive of messenger charges and Connecting Compan

twenty-five (25) per cent of exchange telephone rentals collected, and

() per cent of farmer line rentals collected.

further agree that while acting as agent I will not permit any telephone not leased by THE PACIFIC TELEPHON

ELEGRAPH COMPANY to be located in my premises or placed on lines connecting with my office, except on farme

d others having exclusive connecting agreements with THE PACIFIC TELEPHONE AND TELEGRAPH COMPAN

he Telephone Company reserves the right to terminate this agreement for cause at any time and remove its instr

by giving notice in writing of such termination.

igned at Salada Beach 6-7,7 191

ssion on toll business not to exceed ten cents

n any one switch.

Agent.

by THE PACIFIC TELEPHONE AND TELEGRAPH COMPANY,

MANAGER

Anderson family members operated the switchboard from 8:00 a.m. until 8:00 p.m. Daughter Karin remembered sitting down to dinner and the telephone ringing. "We all looked at each other and someone would say, 'It's your turn. I did it last time.' " Pacific Bell charged 10¢ to connect each call, but money was the last thing on journalists' minds when there was a juicy story to tell. (Jim Coen.)

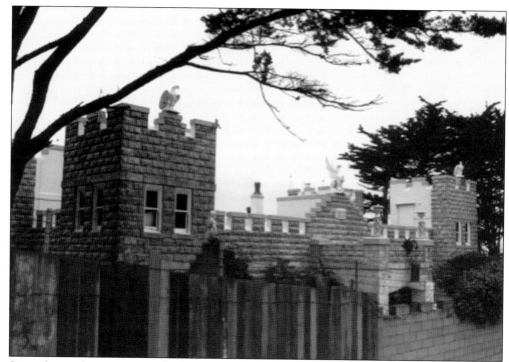

Soon the market was jam-packed with newspapermen lining up to dictate dramatic details to their editors. As it turns out, the bones the reporter dug up were from a chicken. The Millers had buried the items in the garden. It wasn't uncommon to dispose of things in the yard back then, because there was no trash service. When the media firestorm erupted, police arrived with shovels. (Joe O'Brien.)

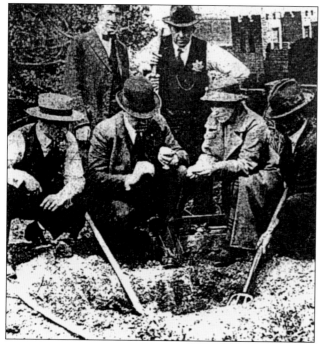

When the five detectives arrives, the door was locked, so they scaled the wall and set about digging. Shown here are San Francisco detective sergeant Miles Jackson, Capt. Duncan Matheson of the San Francisco Police Department, Deputy Sheriff T.C. McGovern of the San Mateo County Sheriff's Department, and Redwood City's Chief Collins and policewoman Katherine O'Connor. (June Morrall estate, photograph by *Other Times*.)

Articles like this one in the *Coastside Comet* only fueled the rumor mill. Like so many others, it reported that "charred human bones" had been found. Nick Gust, Pacifica's former mayor, remembers being warned to stay away from the castle as a child. "They'd scare you to death," he recalled in *Unknown Pacifica*, a documentary detailing Prohibition-era Pacifica history. "God knows what would happen to you if you ever got near the place." (*Coastside Comet*, reprinted in the *Pacifica Tribune*.)

Raid on Mystery Castle by Police

Bodies Reported Found at Old McCloskey Place

(Coastside Comet, Sept. 4, 1920)

Detectives from the San Francisco police department Monday night went to Salada Beach, and raided the old McCloskey place, long known as the "Castle of Mystery," and arrested Dr. Galen R. Hickok, owner of the place, who was found at his home in Berkeley, and charged him on three counts with violating the State Medical laws and on two counts with contributing to the delinquency of a minor.

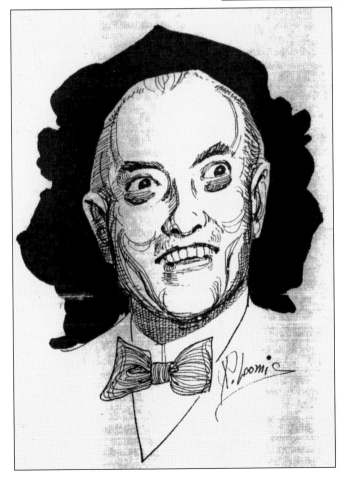

Dr. Hickok, depicted here in a courtroom caricature, said he had never even seen Bertha Casteel before. Hickok's driver, Joseph Kindergren, and the two other patients present in the castle with Bertha acted as witnesses. After seven minutes, the Redwood City jury found Hickok guilty, sentencing him to the harshest punishment available under California Penal Code 274 for administering abortions. (Sam Mazza Foundation/*Other Times*.)

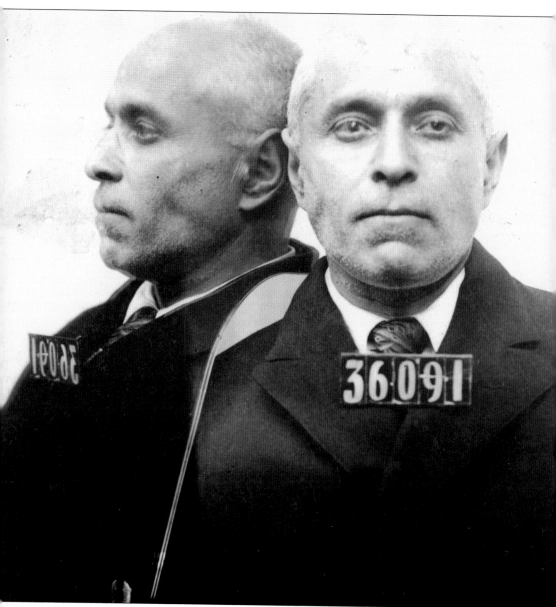

As Hickok started his five-year sentence at San Quentin, a letter arrived, revealing a dark secret from his past. The real Galen R. Hickok from Kansas stated that this fraud had stolen his diploma and papers in 1902. The incarcerated doctor's real name was either Thompson or Zangwell, according to the *California State Journal of Medicine*. While he was a certified naturopath, whether he was ever formally trained as a doctor remains a chilling question. (California State Archives Department of Corrections; 36091.)

People continued to cast sideways glances at the "Castle of Mystery" on the hill, but after the stone fortress was emptied of medical equipment, the rumors died down. Life returned to normal for a year while it was in the hands of a jeweler from Los Angeles. Things would not remain calm for long, however, as the winds of change were gusting in 1920. Roosevelt outlawed the sale, manufacture, and transportation of liquor, and the Ocean Shore Railroad took its last ride, making way for the automobile. (Pacifica Historical Society.)

BIRD'S-EYE VIEW OF SALADA BEACH, CAL.

Once the railroad folded in 1920, developers pulled the plug on big plans for the town. The fog might have kept prospective buyers at bay, but now it drew a new kind of crowd: the rumrunners. If Salada Beach locals thought the Hickok years were crazy at the castle, the new owner, M.L. Hewitt, brought another kind of lawlessness to the castle with late night dancing, dining, and plenty of liquor—despite Prohibition. (Pacifica Historical Society.)

Three

PROHIBITION AND WILD NIGHTS AT THE CASTLE
1920–1933

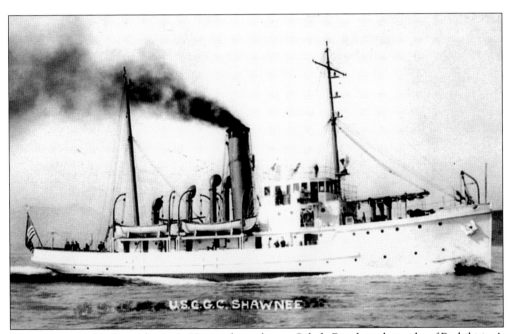

Montana mining industrialist M.L. Hewitt showed up in Salada Beach in the midst of Prohibition's vice grip, but he didn't much care. He aimed to set up a speakeasy, and he was in good company. The jagged cliffs and fog made the town exceptionally difficult to watch, both on land and at sea. Despite the near constant surveillance by the patrolling Coast Guard cutters, such as the *Shawnee*, shown here, rumrunners arrived in droves. (US Coast Guard photograph.)

Dancing **Phone Salada Beach One**

Chateau LaFayette
Cafe de Luxe

We Specialize in

Week End Parties
Dinner Parties
Banquets **SALADA BEACH, CAL.**

(OVER)

At any one time, there were often as many as six Coast Guard cutters patrolling what was known as Rum Row, the stretch between the Golden Gate Bridge and the Pigeon Point Lighthouse. No one dared unload their illicit cargo in San Francisco or Oakland, so Salada Beach became the chosen destination. The word soon spread to thirsty San Franciscans, and the castle became one of seven speakeasies in Pacifica. With dancing and dining overlooking the ocean, Chateau LaFayette was hugely popular throughout the Bay Area; some have even said a spoken password was required after hours. Though it drew high-society crowds, there were also sly characters lurking around. It was not at all uncommon for patrons to be drugged and rolled at the Chateau. (Both, Jim Coen.)

Though Chateau LaFayette was plagued by dramatic police raids that sent patrons scattering into the dark night, M.L. Hewitt went right on serving liquor here in the castle bar area. In one raid in 1923, federal agents confiscated 60 bottles of wine and 25 bottles of whiskey. Hewitt had his own personal interests to protect, so he gladly served as the signaling station for the runners. (Robert Azzaro.)

To make matters worse for the deputy sheriff, home distillers sprang up all over town, and plenty of locals were willing to help. The wide-open coastline made it impossible for police to surprise the bootleggers, and the thick fog made it easy for them to stash their contraband. (John Courtney.)

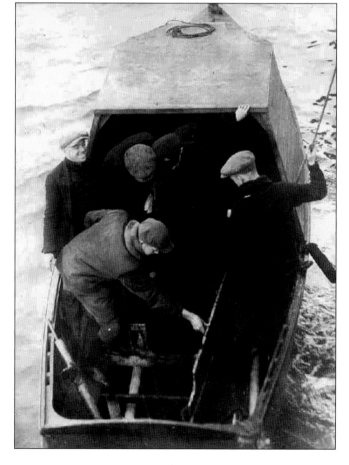

In 1923, a British motor ship called the *Maiahat* slipped past the *Shawnee* cutter and unloaded an estimated $2 million worth of high-grade scotch at Salada Beach. Shown here, a Coast Guard officer investigates some small-time operators. Based on the smile, they likely ditched their illegal cargo just in time. (Photograph by United News Pictures, US Coast Guard.)

There were a few different ways to get the illicit booze ashore. Often, local fisherman would motor out to the whiskey-laden Canadian ships hiding offshore in the fog. It was a huge risk for all involved, but it was so lucrative that people willingly took the chance. Whiskey was $16 a case in Vancouver, and California bootleggers paid $60 a case. They could then sell it for $110 a case to their customers. (*Pacifica Tribune* photograph.)

Another way to unload the booze was to ditch it on the shore and disappear quickly into the fog. One local man, Angelo Pendola (former mayor Nick Gust's father-in-law), would drive his horse-drawn sled down from Vallemar to pick up the cases left on the beach. He would load up the contraband and then bring it up to waiting trucks. His payment was whiskey, and it was well worth it. (Jon Sullberg, *Unknown Pacifica*.)

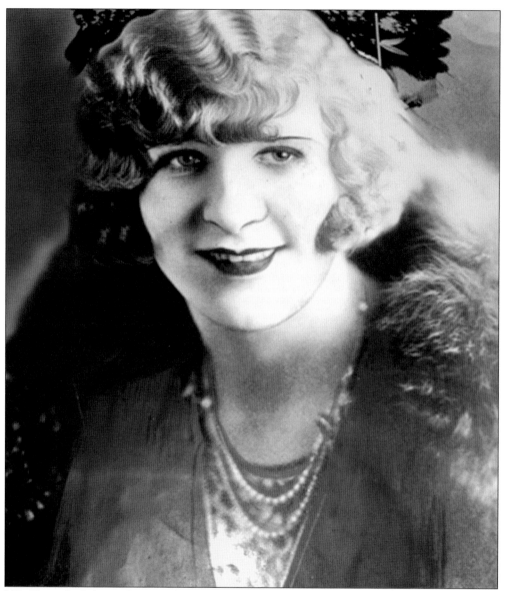

M.L. Hewitt had plenty of room at the castle, and odds are he provided a safe haven for the rumrunners to stash their cases of liquor there. It is rumored that Hewitt and the runners may have had some help from San Francisco's famous madam, Dolly Fine (shown here in 1938), after she rented a weekend bungalow in Salada Beach. (San Francisco History Center, San Francisco Public Library.)

A photographer snapped this image of Dolly's home at 2 Carmel Avenue, which appeared in the April 29, 1938, edition of the *Call Bulletin*. Amazingly, after 70 years, the house looks exactly the same. While there is no proof that she used her Salada Beach getaway as a brothel, there is talk of her bringing her girls down on the weekends—but of course, this cannot be confirmed (or denied). (San Francisco History Center, San Francisco Public Library.)

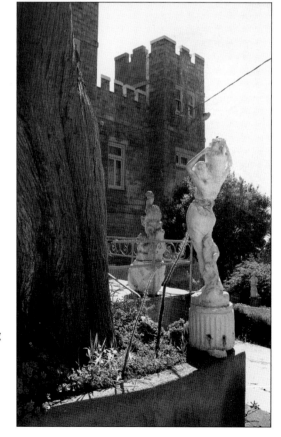

There is also a long-held rumor that the castle once functioned as a house of ill repute. A glimpse into this time was offered to Pete McCloskey while he was holding a constituent meeting in Pacifica. An elderly gentleman introduced himself, saying he was a former California Highway Patrol officer with a beat running the lonely Highway 1 between Santa Cruz and San Francisco. The officer grew accustomed to stopping by the castle to have a cup of coffee with the madam, whom he described as a gracious, kindly woman. (Michael A. Wong.)

In the final days of Chateau LaFayette, the police made one last raid on the classy hilltop restaurant. They scaled the castle walls, barred the front gate, and battered down the front door with battering rams and sledgehammers. Once inside, they found 40 stunned patrons and a tremendous amount of forbidden liquor. They let the revelers go and seized the contraband. (Robert Azzaro.)

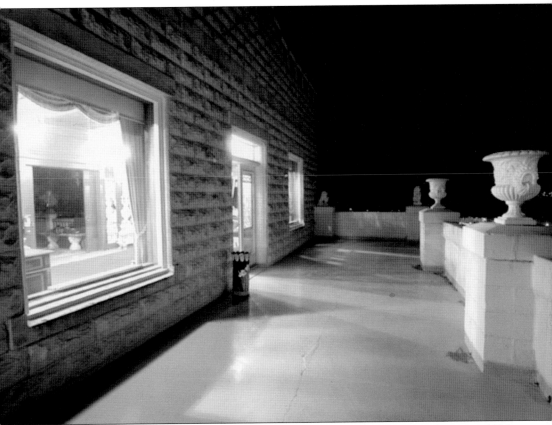

Not long after the calamitous intrusion, M.L. Hewitt became ill, and he passed away in 1924. The nights of fanciful merriment where laughter from this terrace would carry across Salada Beach were over. The rumrunners also had to find another signaling station and place to store their wares. (Robert Azzaro.)

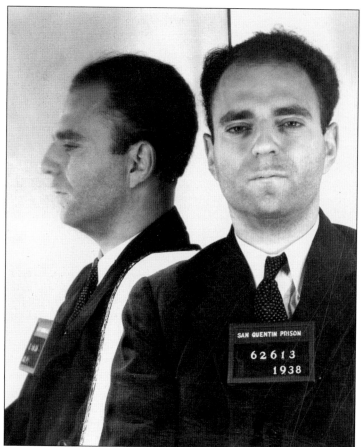

When M.L. Hewitt passed away, the castle transferred to Dr. Hickok's son, Max Hickok. However, he was following closely in his father's footsteps and would suffer the same fate: a jail cell in San Quentin. Though trained as a chiropractor, he was charged with second-degree murder after his patient Elizabeth Sowers from Oakland passed away. (California State Archives Department of Corrections; 62613.)

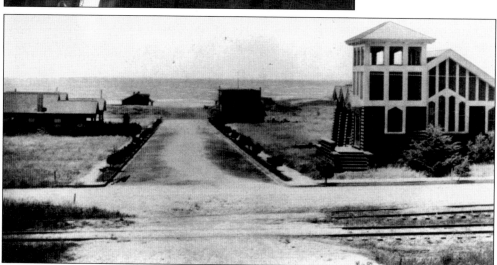

The castle changed hands three more times before a sign painter named Clarence "Holly" Eakin, and his wife, Annie, purchased it in 1928. The Eakins moved in with their adopted son, Charles, and integrated into Salada Beach life. Annie was an active member of the Little Brown Church (shown here), and Holly painted the church's sign, according to special thanks he received in the *Sharp Park Breakers*. (Pacifica Historical Society.)

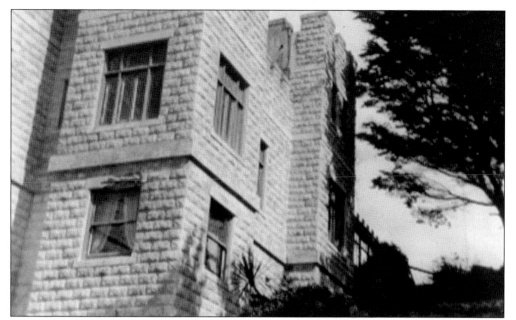

Annie Eakin is also said to have kept an eye on things through her spyglass from high on the hill. However, after December 1933, when the 21st Amendment officially ended Prohibition, there was much less activity to monitor in the small town. This was, no doubt, a huge relief to the local sheriff, as well as Annie Eakin. (Joe O'Brien.)

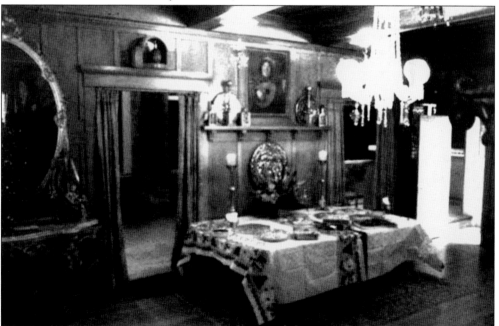

The couple occasionally delighted the locals with charitable gatherings at their stately home. A 1940 article in the *Breakers* reported, "The lights of the Castle smiled a welcome to the many guests who arrived in answer to the Red Cross need for war relief." The guests played whist and other card games, and all entered the raffle. Annie and Maud Haslam also reportedly served delicious refreshments. (Sam Mazza Foundation.)

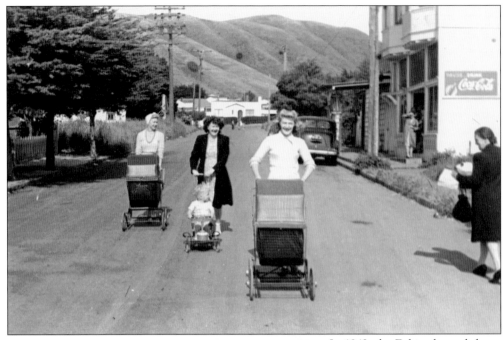

In 1942, the Eakins hosted the wedding reception of Karin Anderson and James Murray, which 63 guests attended, according to an article in the *Sharp Park Breakers*. Karin (left) is shown above later in front of her parents' store with friends and a baby in tow. (Jim Coen.)

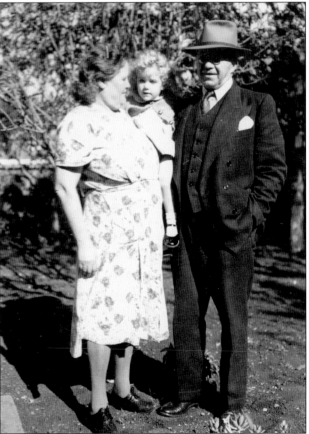

Bertha and Math Anderson, shown here with granddaughter Kate, celebrated the nuptials of their daughter and James decades after their own reception at the castle in 1916. Not long after the wedding, Holly and Annie turned their castle home over to the US Coast Guard to support the war effort. (Jim Coen.)

Four

THE US COAST GUARD
1942–1943

After the bombing of Pearl Harbor, the Coast Guard's Beach Patrol was dispatched to the coast to watch for enemy submarines and saboteurs. The Coast Guard rented the castle from the Eakins, and Company H (1st Platoon, 12th Regiment) moved in on November 18, 1942. Their war dogs were housed in kennels next door. (Deb Wong.)

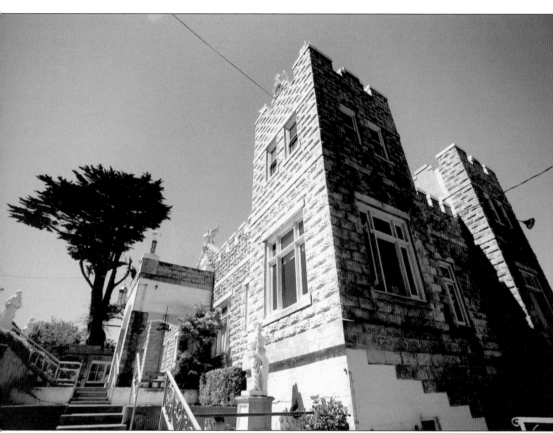

It was cramped quarters for Lt. James Carr and the 13 enlisted men, and there was inadequate power to feed the hungry servicemen. At the time, PG&E could only install lines up to 250 feet, but it was 287 feet to the castle. Reportedly William Randolph Hearst heard about the PG&E line problem and not only paid for the lines but personally made sure they were installed the day before Christmas. (Robert Azzaro.)

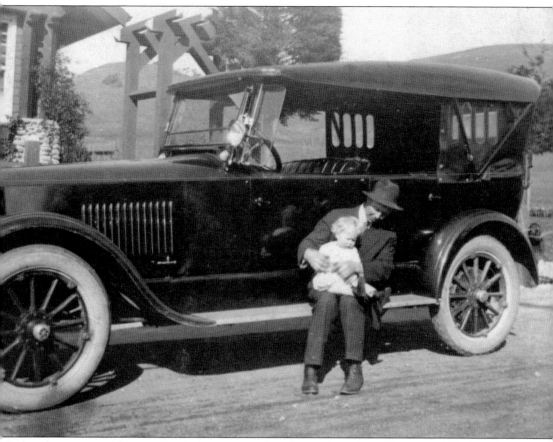

Before the power problem was fixed, the men ate a lot of canned goods and frequented Math and Bertha's market. Many of the servicemen befriended the Andersons and remained lifelong friends of the family. Math, shown here with granddaughter Kate, remained a fixture in town—only now he had a bigger car. (Jim Coen.)

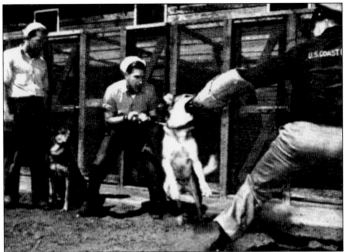

The Coast Guard was proud of their patrolling canines, as they felt the dogs symbolized the fighting spirit. They were trained to be fearless, aggressive, and ready for anything. Each seaman was assigned his own war dog. "No one else had anything to do with that dog," Gale B. Feick, a Company H guardsman, recalled in a *Gatewatch Call* article. (Sam Mazza Foundation.)

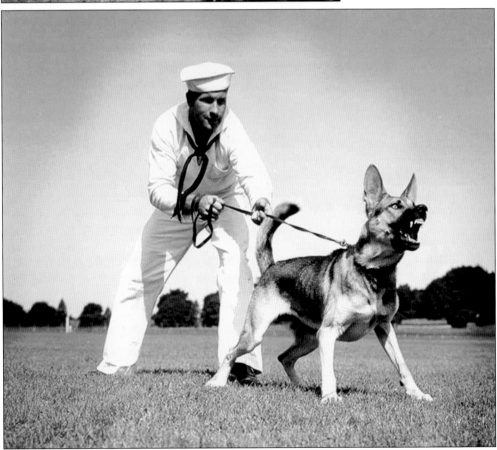

"We each fed our own dog, patrolled with it and so forth," Gale B. Feick remembered. "You'd be out there on the beach, freezing to death and so weighted down with equipment and bundled up that you could hardly move. On top of that, you had your dog pulling you along like crazy!" The men patrolled all the way from Mussel Rock to Rockaway Beach and back with their dogs. (US Coast Guard photograph.)

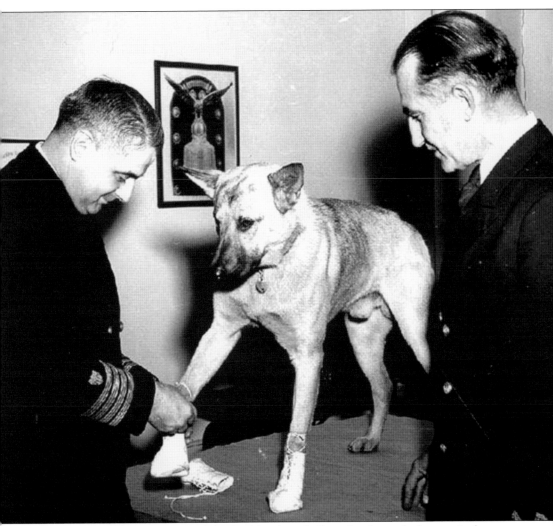

These lace-up canvas booties protected the dogs' feet from shells and rocks on the long anti-saboteur beach treks. The men were required to patrol alone, and Lt. James Carr is said to have sometimes hid out in the rocks along the beach to make sure they weren't standing around talking. If they were caught talking— or worse, napping—they were given extra duties, like scrubbing the castle floors. When Gale B. Feick returned to visit the castle, he remarked on the floors he had spent so much time polishing. (US Coast Guard photograph.)

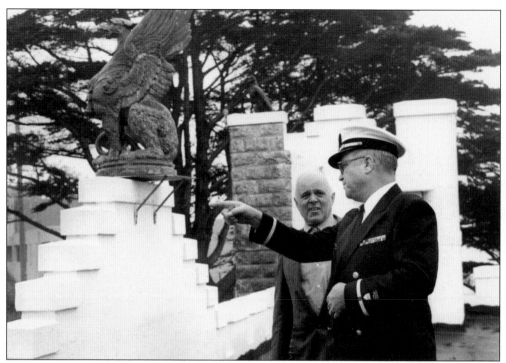

Twenty-four years after he left the castle with his fellow guardsmen of Company H, Gale B. Feick returned in full dress for a nostalgic tour of his former barracks. Shown here on the roof of the castle with Sam Mazza, he points out exactly where the patrol dogs were housed. (*Pacifica Tribune* photograph.)

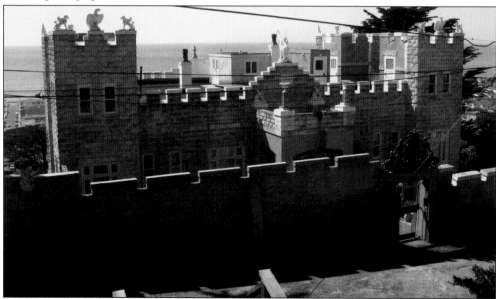

Gale B. Feick wasn't allowed up on the roof when he had lived at the castle. Only the old salts got to live in the turret rooms, while the servicemen bunked downstairs. "Of course, in those days," Feick recalled, "you were an old salt if you'd been in the Coast Guard longer than 30 days." (Deb Wong.)

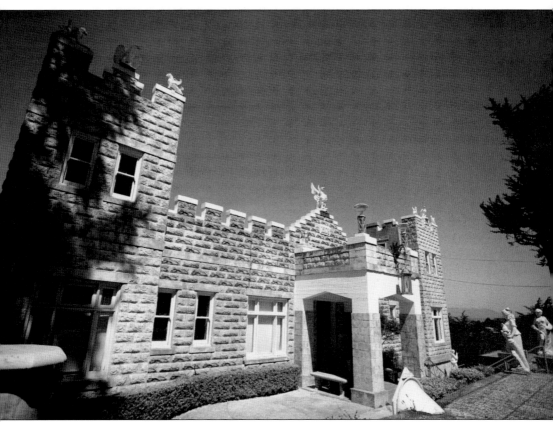

During their time at the castle, the guardsmen only had one scare. While on night patrol, a guard heard a shot, and a bullet whizzed over his head. He sprinted back to the castle, as there were no telephones nearby. He reported they were under attack, and Carr promptly phoned it in. As it turns out, however, a fellow patrolman had found a bullet and experimented, never having shot a gun before. Company H left much damage behind, and the Eakins received a settlement when they moved back in. (Robert Azzaro.)

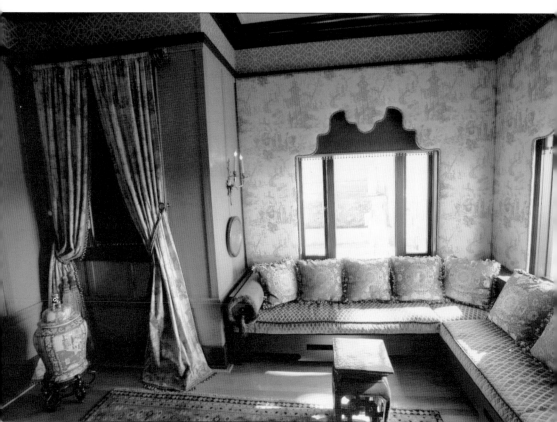

Annie Eakin reportedly lived with as many as 20 cats at the castle after Holly died in 1953 and Charles was institutionalized. She told *Westlake Times* reporter Edna Laurel Calhan during their December 14, 1955, interview that she wasn't lonely. "She explained she had books to read and she waited for Charles's return." One can picture her reading here in this lounge. After her death, Annie's nephew G. Howard Johnson inherited the castle in 1956. He then rented it to a sculptor named Joseph Patrick O'Brien and his family. (Robert Azzaro.)

Five

ARTISTS IN RESIDENCE
1953–1958

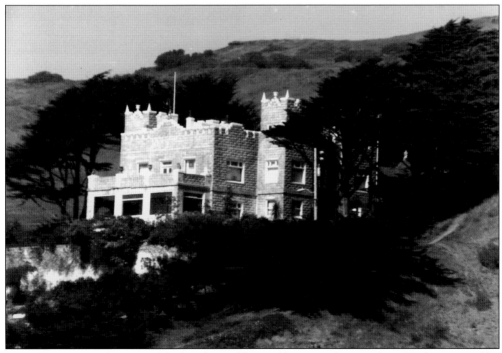

Joe O'Brien was eight years old when he and his mother were driving along Highway 1 and he spotted the grand castle up on the hill. "Isn't it beautiful?" his mother Nora asked. "I wonder if the owners would let us in. Maybe they would give us a tour?" Joe couldn't believe his luck that his mother was actually willing to drive them up there. (Sam Mazza Foundation.)

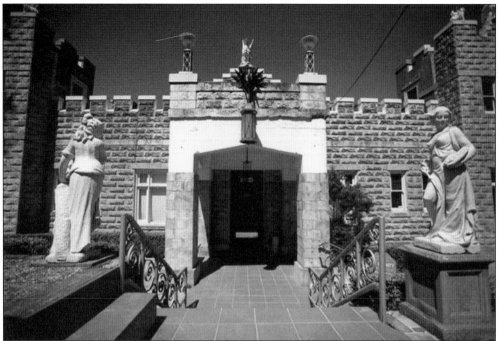

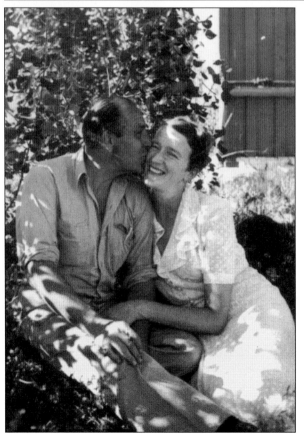

Little did he know, his parents had rented the castle and planned to surprise him. Standing excitedly outside the gate, Joe O'Brien rang the bell, and to his astonishment, his father answered the door. Joe was ecstatic, and over the next five years he explored every inch of the fortress. He not only discovered secret compartments, he also encountered ghosts—and he wasn't alone. His mother also had a ghostly encounter, and 50 years later, professional ghost hunters had some interesting findings as well. (Robert Azzaro.)

Pat and Nora O'Brien, shown here, settled in with four of their six children: brothers Kerry, Mike, and Joe and sister Brian. When Pat set up his sculpting workshop downstairs, Joe recalls that he found a bottle of whiskey. "He said we must never touch it as it could be poison," Joe remembered. "After awhile the bottle was empty. Dad said it was the best whiskey he'd ever tasted." (Joe O'Brien.)

Pat O'Brien worked diligently on his sculptures in his castle workshop. While learning his craft, he'd had the good fortune to train under Gutzon Borglum, the Mount Rushmore master. O'Brien left his enduring mark on the castle by putting this submarine portal in the front door. A close-up of O'Brien's handiwork is shown at right, with the king of the castle, Sam Mazza. (Right, the *Wave/Pacifica Tribune* photograph, Sam Mazza Foundation; below, Robert Azzaro.)

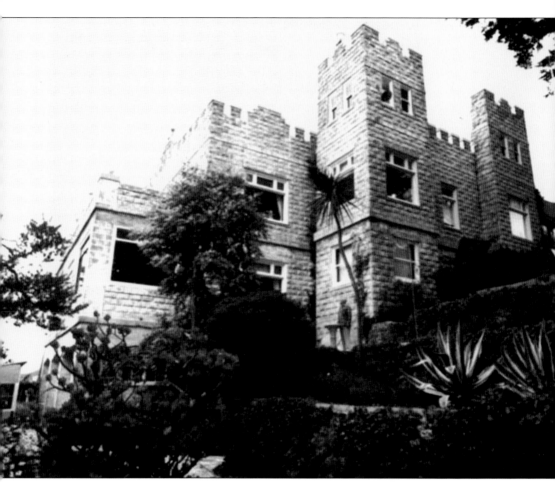

Years later, Joe O'Brien paid a visit to his childhood home, where he met Sam Mazza. "Sam told me he had heard a mad sculptor had lived there with a retarded son. I laughed at this, telling him I guess I was the retarded son. Amazing how rumors get started," Joe mused. Like Mazza, the O'Briens received several unsolicited guests (living and unliving) during their time at the castle. "We'd be having lunch and look out to see strangers wandering around the garden," Joe recalled. "We ended up charging admission on weekends for tours." (Sam Mazza Foundation.)

Joe O'Brien lived in several rooms around the castle, but his first ghostly encounter took place in the small bedroom with the adjoining bathroom. One night, as he was drifting off to sleep, the light came on. Because it took some force to push the button on the old-fashioned switch, he was puzzled and then frightened. But he got up, turned out the light, and jumped into bed. (Robert Azzaro.)

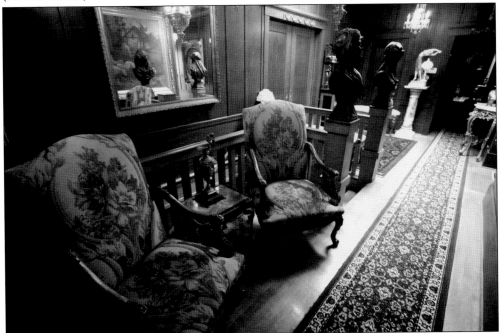

When the light went on again, Joe O'Brien thought his brother was playing a trick on him. He opened his bedroom door and peeked down the hall, but all was silent. Now he was scared. He quickly pushed the switch in again and jumped back into bed. When the light came on a third time, he left the lights on all night. Was this an electrical malfunction, or otherworldly visitors? (Robert Azzaro.)

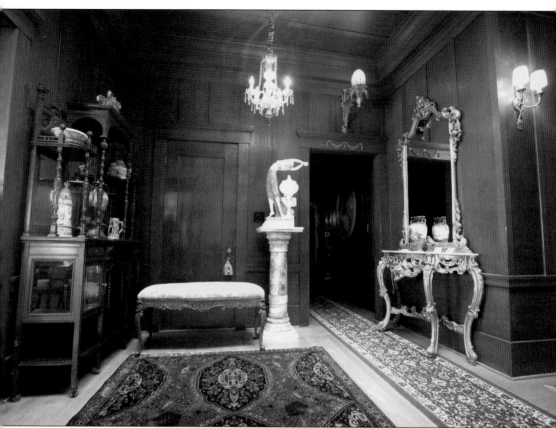

Nora O'Brien encountered her ghost in the upstairs hallway. "Mom was a no-nonsense gal," said Joe O'Brien. "When she said she'd seen a ghost, we all listened." While walking toward her bedroom down this hallway, she saw something white and shadowy at the end of the hall. (Robert Azzaro.)

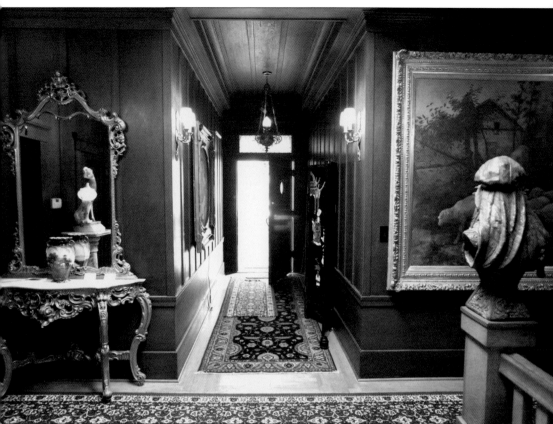

Nora O'Brien backed up against the wall, and the white figure moved toward her. She felt a cold draft as it passed, and she watched it drift out the front door. In 2010, contractors refurbishing the castle reported seeing a shadowy figure in the window and that their tools had mysteriously moved. (Robert Azzaro.)

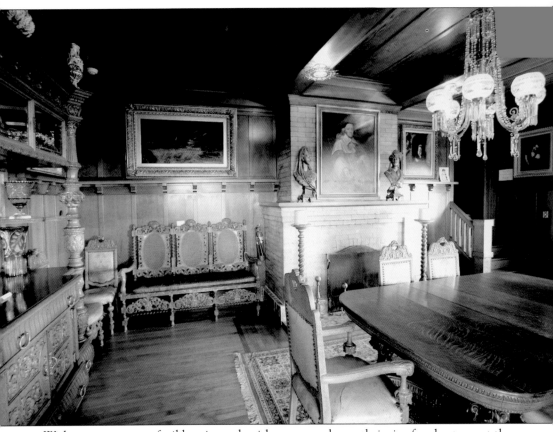

With over a century of wild antics and quirky owners, the castle is ripe for ghosts, or at the very least, ghost tales. On July 3, 2010, a team of paranormal investigators from *Ghost Explorers* came for concrete evidence. At 11:33 p.m., a recorder on the stairs facing the dining room picked up two men greeting each other. On playback, the camera showed no one was near. The recordings can be found on the *Ghost Explorers* website. (Robert Azzaro.)

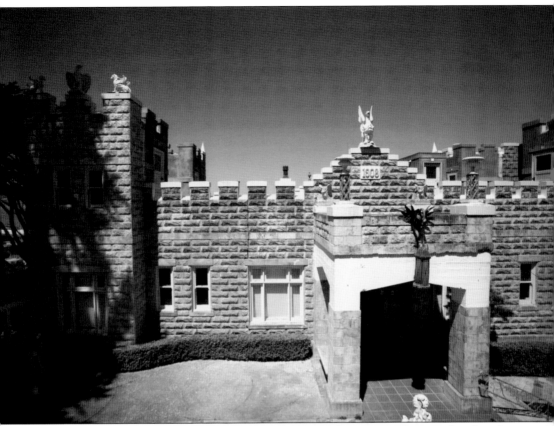

The patient ghost hunters picked up another electronic voice phenomenon (commonly referred to as EVP) in the southwest turret room when an investigator felt something on his head. He said it must be a bug, and a faint whisper was recorded. Half an hour later, the investigator asked if that room was the lookout tower, and an audible sigh was heard on both recorders. (Robert Azzaro.)

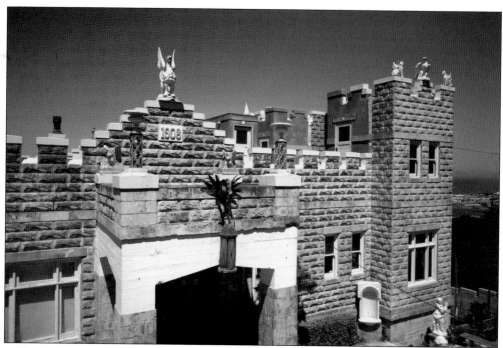

Though young Joe O'Brien was brave enough to sleep up in a turret room, it doesn't mean he never got spooked. He chose the northeast room (shown here) because he said the southeast one "didn't feel right." But one night he got a good scare when a rainstorm blew his door open. "It was banging around and I remember looking out, but I was too scared to get up!" (Robert Azzaro.)

"Suddenly, there was this cloaked figure in the doorway and I nearly wet my pants!" Joe O'Brien remembers. It turns out his father was sculpting a bishop and had the robe lying around. Joe's brother Mike (shown here), who was home visiting from the Air Force, heard the door banging and put on the robe and hood to shield him from the rain when he came up to investigate. (Joe O'Brien.)

For years, castle residents—like Paul McCloskey, Coast Guard servicemen, and Joe—have traversed these stairs to the roof. Joe made it his mission to explore every inch of the castle. "I walked around with a broom, tapping on everything," he said. "I climbed all over that place." One can imagine his delight when he discovered a hidden compartment in the stairwell. (Bridget Oates.)

A testament to Math Anderson's craftsmanship, the latched door was seamlessly crafted to avoid detection, even of a curious eight-year-old boy. To a contractor, it would simply be a portal to electrical and plumbing equipment, but to a young boy, it was a magical discovery and an exciting place to hide in and explore. (Bridget Oates.)

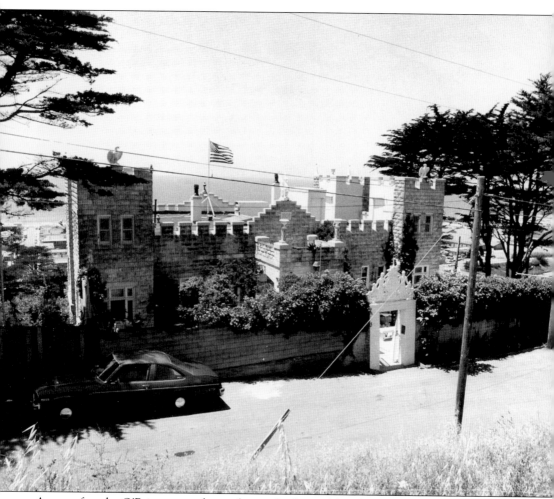

A year after the O'Briens moved out, the castle changed hands one last time. Sam Mazza was headed to Nick's in Rockaway Beach with his girlfriend, Mary, who would later become his wife. As they zipped along Highway 1, he looked up at the charming grey stone turreted home nestled in the trees and decided to investigate. Fate smiled on the treasured Pacifica landmark that day. (Sam Mazza Foundation.)

Six

An Italian Gentleman, Sam Mazza
1959–2002

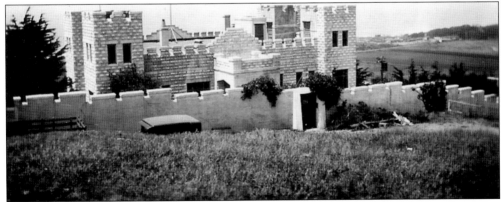

When Sam Mazza first laid eyes on the castle in 1959, he recalls, "I had had one too many gin fizzes and I was feeling no pain. I looked up and saw this 'big pile of bricks' and decided to buy it." Though the asking price was $35,000, they agreed on $29,000, and Mazza walked away with the keys to the castle. (Joe O'Brien.)

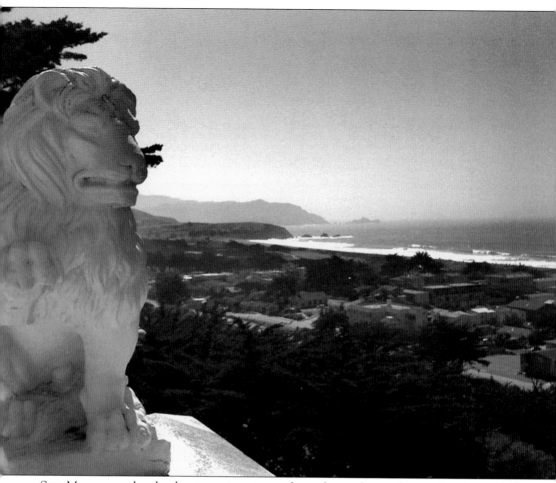

Sam Mazza was taken by the staggering view and saw the castle as a diamond in the rough, but his friends, who already called him the white elephant collector, thought he was crazy. "What nobody else wanted, I bought," Mazza laughed. "You should have seen this place when I bought it!" With his characteristic humor, Mazza hoisted a "Sam's White Elephant" flag off the rooftop. (Bridget Oates.)

The castle was in grave disrepair, with broken windows and weeds four feet high when Mazza purchased it. Right away, Mazza sank $20,000 into refurbishing the castle. He replaced windows, landscaped, and installed marble procured from his brother's marble-sculpting friend, as seen here. (Sam Mazza Foundation.)

Sam Mazza and his wife Mary never planned on living in the castle; they already lived, ironically, on Hearst Avenue in San Francisco. Their Sunnyside District home, which had once housed all nine Mazzas, was purchased by Sam's father, Antonio, for $10 down and payments of $10 a month. So in their absence, vandals had plenty of opportunity to wreak havoc in the garden. (Sam Mazza Foundation.)

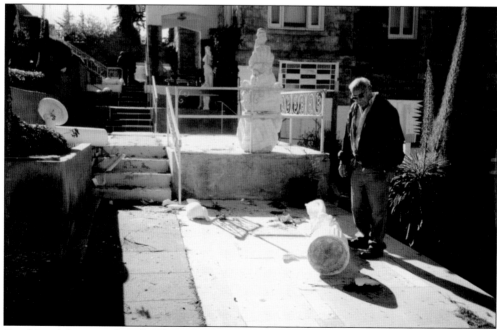

Sam Mazza's longtime friend and groundskeeper Ray Gracia (shown here) helped them clean up the mess. Yet, soon after, the new windows were broken out once again. Mazza called on the Pacifica police for advice, and that is when he found out about the rumors. (Sam Mazza Foundation.)

Many folks in town believed the castle was haunted, which inspired curious kids to sneak up there late at night to try to scare out the ghosts with rocks. Only now, those rocks met with Sam's brand new windows and statues. The Pacifica police were no strangers to the castle. If they weren't chasing off the kids, they might be responding to an alarm—but at least they no longer needed to scale the high surrounding walls, as officers often did in the 1920s. (Sam Mazza Foundation.)

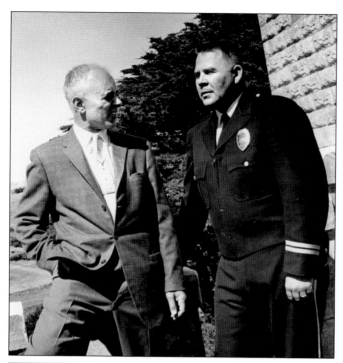

After Pacifica's police chief Neil Tremaine (right) told the Mazzas about the kids, Sam hatched a plan to curb the vandalism in the best way he knew how—a party. (Sam Mazza Foundation.)

Pacifica Tribune — July 16, 1959

Ghosts Gone, Says Castle King

Kids Find Only Cokes in Tour; Trouble Ceases

Hundreds of inquisitive Pacifica youngsters this week searched Sharp Park's ghostly castle—but all they found was free Cokes.

The kids had been invited by the Castle's new owner, Sam Mazza, in the hope that letting the youngsters in would end the wave of forced entries that had been plaguing him.

Apparently it worked.

This was the first week in months that police have had no report of damage at the Castle.

"In all its 52 year history," Mazza wrote in a letter to the Tribune, "I doubt if a happier time has been held within its interesting walls.

"My only wish is that Scotty McCluskey, the original owner and builder, could have seen the youngsters' happy faces as they scampered through the halls of the structure he decided to build in 1907."

"If there has been any curiosity in the minds of anyone regarding ghosts inhabiting the castle, let them now dispel

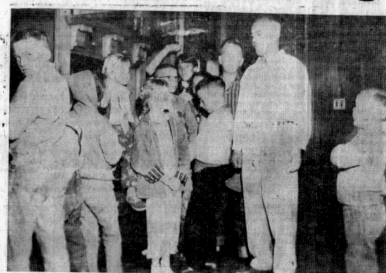

GETTING THE INSIDE STORY FROM CASTLE OWNER SAM MAZZA, YOUNGSTERS GATHER 'ROUN
On tour are David, Steven, Theresa and Karen Fredericks, Karen Girton, Lamont McMahan, Raymond

Sam Mazza threw a Coca-Cola party so the kids could see for themselves that there were no ghosts, and, amazingly, it worked. In a July 1959 *Pacifica Tribune* interview, Mazza said, "My only wish is that McCloskey, the original owner and builder, could have seen the youngsters' happy faces as they scampered through the halls of the structure he decided to build in 1907." (*Pacifica Tribune* photograph.)

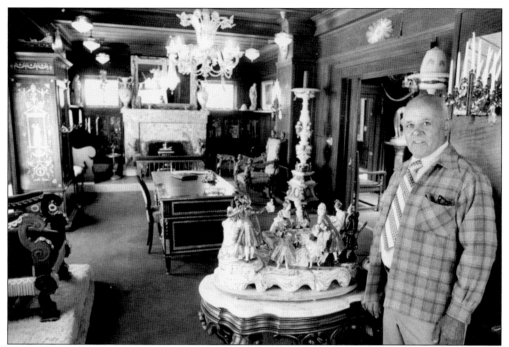

That was the last of the vandalism, and Sam Mazza went back to filling the castle with his priceless antiques and movie memorabilia. This Dresden porcelain piece was one of his prized possessions. He also had a soft spot for "junk" and kitschy bric-a-brac, as he affectionately called it. He and Mary frequented garage sales, flea markets, and estate liquidations. The castle remains an enduring testament to his exquisite taste, along with his sense of whimsy. (Sam Mazza Foundation.)

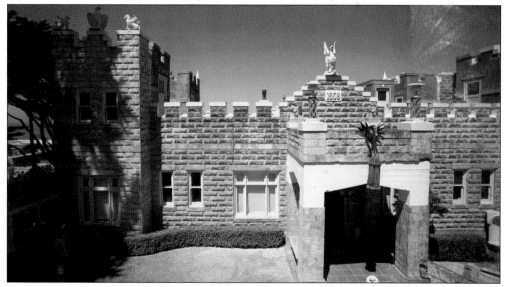

Years ago, passersby would have seen large, round, rubber balls hanging off each of the white cones shown here atop the castle turrets. Sam Mazza took great pleasure in telling people those balls were actually toilet floats that he had had painted white. Though they have all been carried off by Pacifica's high winds, and the rusted white metal cones have been dismantled, Mazza's sense of humor lives on in the story. (Robert Azzaro.)

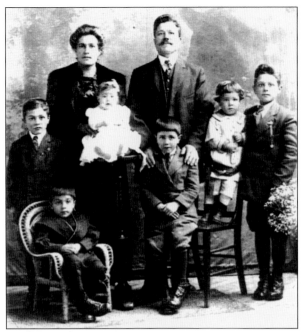

While Sam Mazza loved to play, he also had a strong work ethic that was inspired by his father. Antonio Mazza struggled to provide for his large Sicilian family during the Depression, sometimes earning just $1 for a 14-hour workday. Sam Mazza and his brothers left school to work, though he later attended trade schools where he discovered his painting talent. (Sam Mazza Foundation.)

THE UNITED STATES OF AMERICA

TO BE GIVEN TO THE PERSON NATURALIZED

No. 3841845

CERTIFICATE OF CITIZENSHIP

Petition No. 31160

Personal description of holder as of date of naturalization: Age 29 years; sex male; color white; complexion dark; color of eyes brown; color of hair black; height 5 feet 9 inches; weight 150 pounds; visible distinctive marks none

Marital status single race former nationality Italian

I certify that the description above given is true, and that the photograph affixed hereto is a likeness of me.

ORIGINAL

Sam Mazza

(Complete and true signature of holder)

UNITED STATES OF AMERICA
NORTHERN DIST. OF CALIFORNIA } ss:

Be it known, that SAM MAZZA then residing at 414 Hearst Ave., San Francisco, California having petitioned to be admitted a citizen of the United States of America, and at a term of the District Court of The United States held pursuant to law at San Francisco on November 19th 1934 the court having found that the petitioner intends to reside permanently in the United States, had in all respects complied with the Naturalization Laws of the United States in such case applicable, and was entitled to be so admitted, the court thereupon ordered that the petitioner be admitted as a citizen of the United States of America.

In testimony whereof the seal of the court is hereunto affixed this 19th day of November in the year of our Lord, nineteen hundred and Thirty-four, and of our Independence the one hundred and Fifty-ninth.

WALTER B. MALING,

Clerk of the U. S. District Court.

By _____ Deputy Clerk.

Salvatore Mazza

Seal

DEPARTMENT OF LABOR

Sam Mazza received his citizenship in 1934. He is said to have spoken often about how proud he was to have been a poor boy from Sicily who was able to make his dreams come true in America, thanks to unyielding tenacity and hard work. (Sam Mazza Foundation.)

Sam Mazza excelled at painting and restoration, which led him to open his own painting contractor business. His skillful, high-quality work quickly attracted clients, including the prestigious cathedral-like Fox Theatre on Market Street. Mazza masterfully restored the interior, which led him to other lucrative projects, including the Presidio, the Coca-Cola building at Thirteenth and Mission Streets, the George Mann theaters, and various supermarket chains. (Sam Mazza Foundation.)

Sam Mazza, shown here looking quite dapper, was born in Piedimonte Etneo in Catania, Sicily. Mazza came to America with his parents just before his fifth birthday. The young family boarded the *Duca di Genova* steamer out of Naples and got their first glimpse of the Statue of Liberty 12 days later while disembarking at Ellis Island. (Sam Mazza Foundation.)

With Sam Mazza's appreciation of movies and the arts, he was a perfect fit for the Fox Theatre. Shown here with a glamorous couple, Mazza (left) began collecting movie memorabilia and never looked back. The castle holds items from a variety of theaters, including a mirror procured from Paramount, gold curtains, statues, and a cape possibly worn by Clark Gable, to name a few. (Sam Mazza Foundation.)

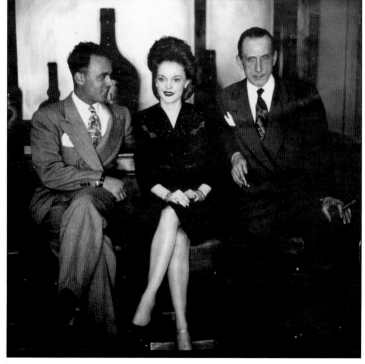

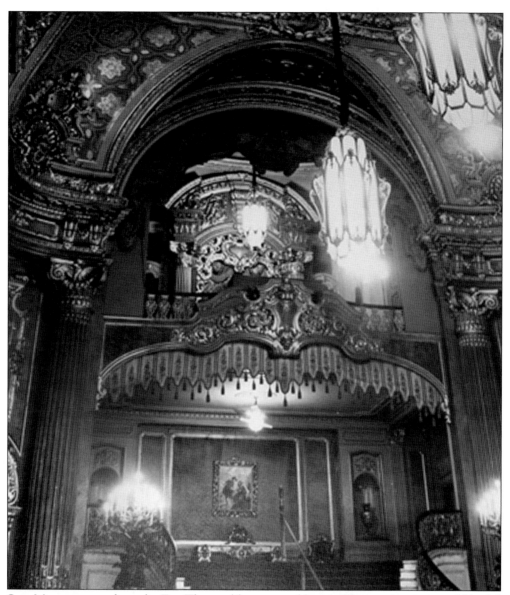

Sam Mazza grew to love the Fox Theatre like a second home. The awe-inspiring, gold-leafed ceiling and rich tapestries were a thrilling spectacle of opulence that no doubt fueled Mazza's own movie memorabilia collecting hobby. Reportedly, he was in the audience when Will Rogers presided over the opening ceremonies in 1929. The colossal movie palace boasted 4,651 seats and was a massive undertaking for Mazza, but he loved every minute of it. His talents at painting and decorating the grand Fox Theatre opened many more doors around town, and soon Mazza's painting business was flourishing. (San Francisco History Center, San Francisco Public Library/family of Larry Moon.)

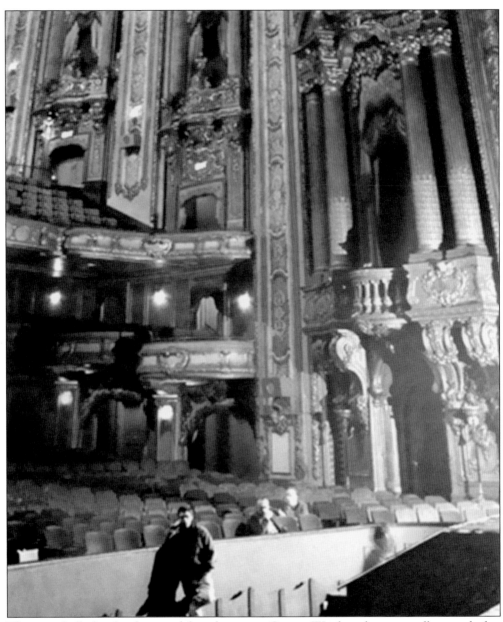

The great hall also deeply moved famed organist George Wright, who reportedly stayed after hours to play. He would remove his coat and tie and fill the rafters with dramatic melodies on his Mighty Wurlitzer theatre pipe organ. On February 16, 1963, the theater's last night, George symbolically removed his coat and tie before the audience and played "I Left My Heart in San Francisco" as the organ slowly descended into the orchestra pit. (San Francisco History Center, San Francisco Public Library/family of Larry Moon.)

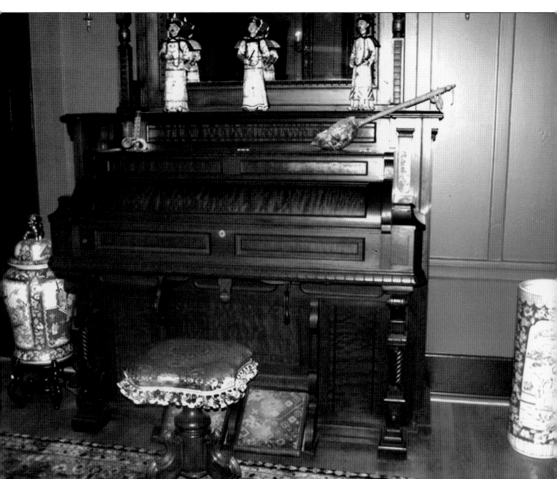

It is possible George Wright's dramatic flair stayed with Sam Mazza, for when he saw the organ shown here, he simply had to have it. But there was just one problem: the owner wasn't selling. He asked many times, many different ways, but she flatly refused. She did, however, need a buyer for her house. Mazza saw his opportunity and offered to buy her house if she would include the organ in the sale, and she agreed. He turned around and sold the house right away, but he finally walked away with his prized piece. (Bridget Oates.)

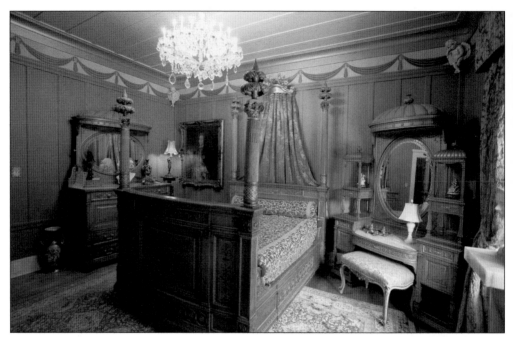

Another prized addition to Sam Mazza's collection was this bedroom suite said to be over 200 years old when he acquired it in 1962. Mazza painted Flora Kolder's house in exchange for the ornate pieces she had owned for 32 years. It took six years for creator Vernis Martin to finish the four-piece, gold-sprayed set. The Crocker family then bought it second hand in Paris for $5,060 and owned it for 54 years. When it was auctioned at Butterfields, the eccentric Madame Tessie Wall purchased it. After her death, it returned to Butterfields, where the sheriff of Sacramento, Ellis Jones, and his wife, Flora, snapped it up. Mazza also had a bed slept in by Pola Negri, the silent screen vamp of Valentino fame, but it was dismantled for lack of space. (Both, Robert Azzaro.)

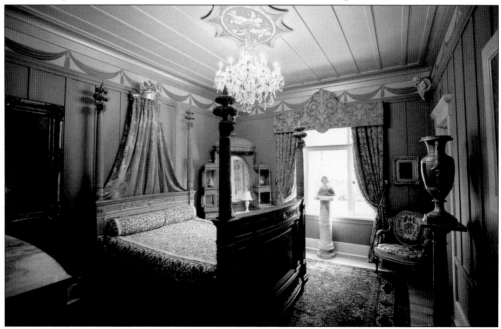

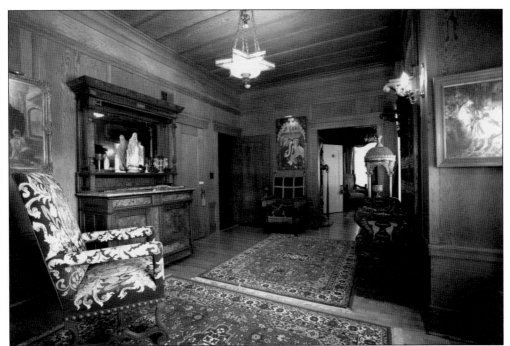

Sam Mazza's passion for collecting led him to acquire antique furniture, a jade and black lacquer screen once owned by William Holden, stained glass windows, Tiffany lamps, delicate china, and even swords. No castle would be complete without a throne or a suit of armor. Mazza had those too. (Robert Azzaro.)

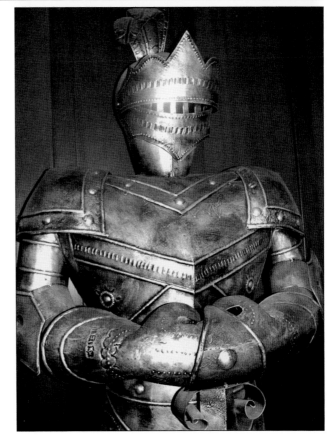

While Sam Mazza's stately knight hails from the theater and not the battlefield, he looks the part, and that is what matters most. Much of Mazza's collection was procured from various theaters around San Francisco, and the items look far heavier than they actually are. (Bridget Oates.)

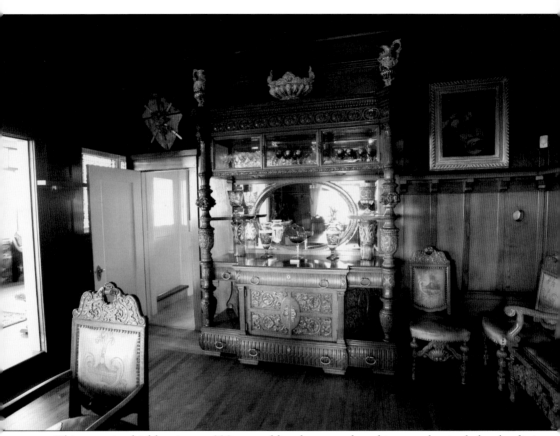

This stunning highboy is over 300 years old and was purchased in a set that includes the dining room table and 10 chairs—all made of golden oak. These historical pieces were originally showcased in a Russian Hill mansion built by Judge James McMillan Shafter in the 1860s. It was sold to C.C. Rohlff before Sam Mazza purchased it. (Sam Mazza Foundation.)

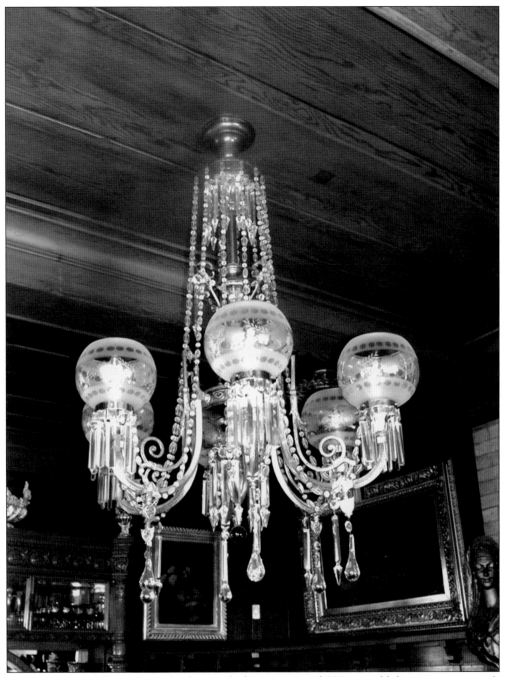

Sam Mazza found the perfect complement for his exceptional 300-year-old dining room set with this fancy six-light crystal chandelier. Hung majestically over the dining room table, the light fixture was gilded with a thin coating of gold, which was commonly applied to beautify historical pieces such as this. (Bridget Oates.)

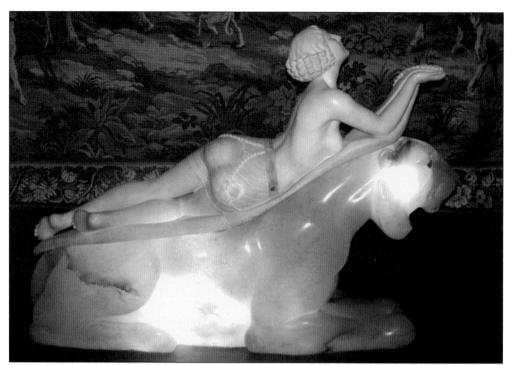

This gorgeous alabaster and marble lamp of a lady and a lion is one of the most outstanding pieces in Sam Mazza's collection. He and Mary enjoyed going to auctions, where they found many priceless marble statues. The stunning pieces adorn nearly every room in the castle. (Both, Bridget Oates.)

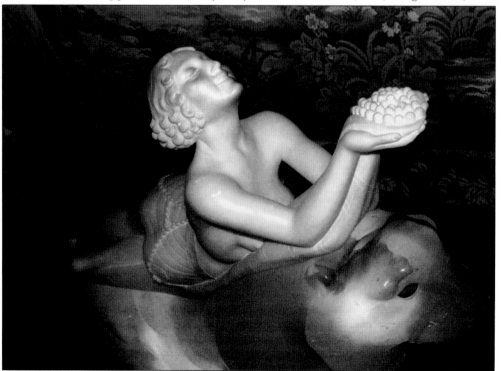

In addition to the well-lit lady and lion statue on the previous page, Sam Mazza's collection boasts several priceless marble lamps, which add a beautiful ambiance to many rooms in the castle. It is likely they were purchased on one of Sam and Mary's many trips to Bonhams and Butterfields Auction House. (Bridget Oates.)

This beautiful marble leaning lady adorns the redwood-lined front entry hall. Perched on a tall marble pedestal, she stands on tiptoe, arching over a petite light fixture with a bare midriff and flowing skirt. (Robert Azzaro.)

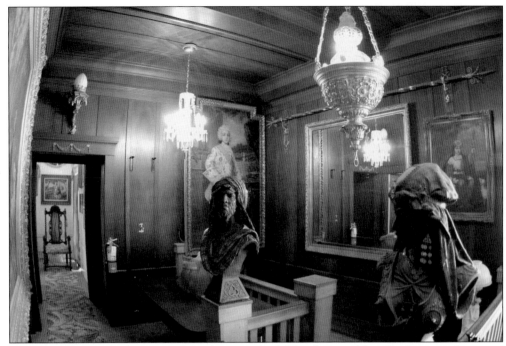

These two Moroccan busts guarding the stairs look like they could really do some damage if they fell, but they were created for the theater and are not actually made of bronze. Sam Mazza collected many such pieces that can be seen throughout the castle. (Robert Azzaro.)

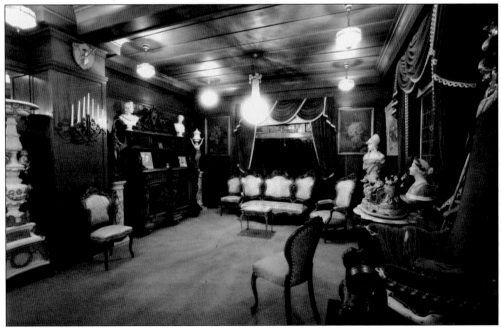

In the living room is the castle throne (right), where many a king and queen have sat over the decades. With plenty of seating for all in the grand, palatial room, Sam and Mary Mazza could entertain a large number of guests. They were known to seat up to 40 people in what is now the bar area/ballroom for grand dinner parties. (Robert Azzaro.)

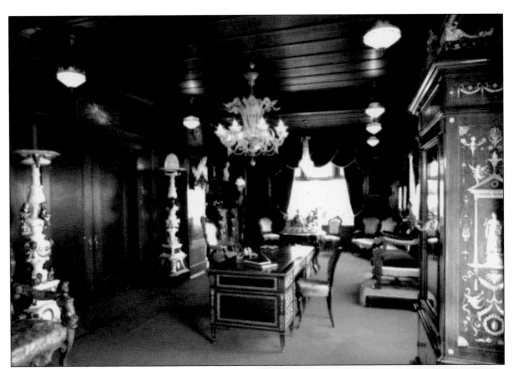

Sam Mazza liked Louis XVI–style desks so much that he had two of them. This mahogany, brass-mounted gem commands the living room. (The other desk can be seen on page 26.) (Sam Mazza Foundation.)

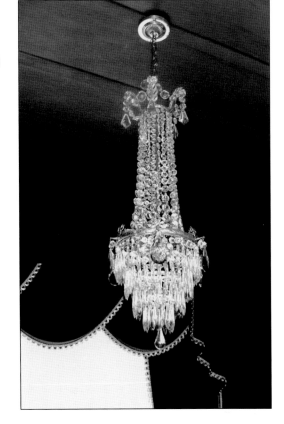

There are several exquisite chandeliers throughout the castle, and the large living room boasts three of them. The beauty shown here was made in France in the 1920s, and it has a matching twin on the opposite side of the room. The large chandelier in the center of the room (shown above hanging over the desk) was made in Venice, Italy. (Bridget Oates.)

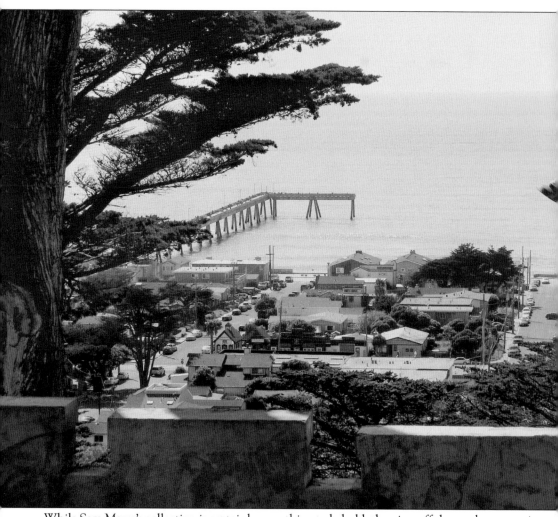

While Sam Mazza's collection is certainly something to behold, the view off the castle parapet is awe-inspiring. In November 1973, guests of the castle got a new view as the Rev. Herschell Harkins Memorial Pacifica Pier was completed. Fishermen still crowd onto the L-shaped pier to lure in the western striped bass that Sharp Park Beach is famous for, as well as salmon. (Deb Wong.)

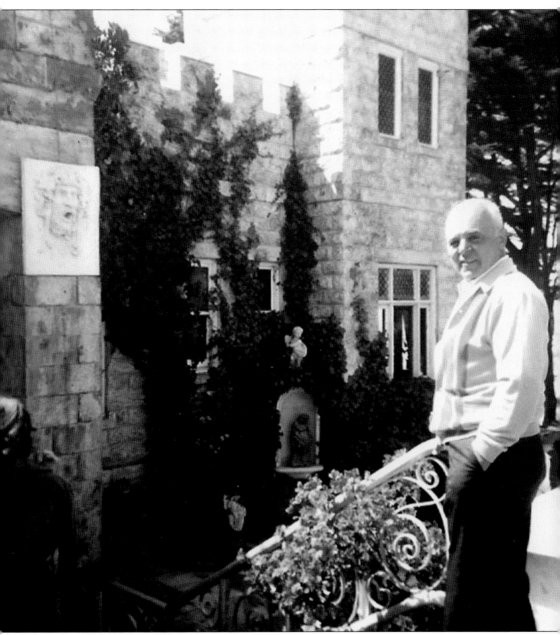

Sam Mazza, shown here in the early 1970s, devoted himself to caring for the castle. He would often come down from his San Francisco home to tend to things, but he also took time out to relax with friends or even trade stories at the local barbershop. (Sam Mazza Foundation.)

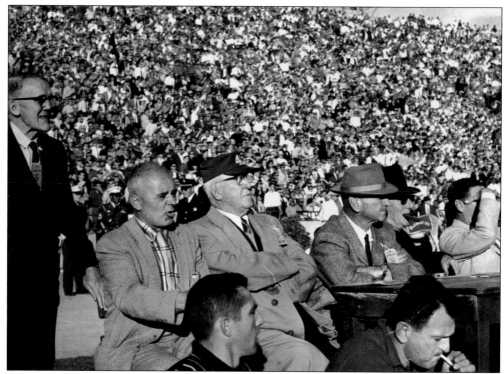

When Sam Mazza (second from left) wasn't at auctions or relaxing at the castle, he liked to take in a football game with San Francisco's movers and shakers at Kezar Stadium. To the right of Mazza is George Mann, owner of a chain of theaters throughout San Francisco. Mann lived in St. Francis Woods and liked to invite friends to his home for movie night in his 100-seat in-house theater. Mazza's high society affiliations brought many interesting people to the castle over the years, as seen in the next chapter. (Both, Sam Mazza Foundation.)

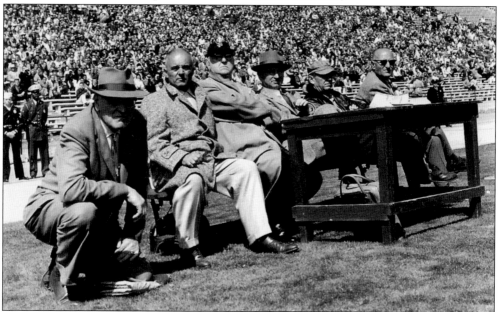

Seven

SAM'S LAVISH PARTIES
1960–PRESENT

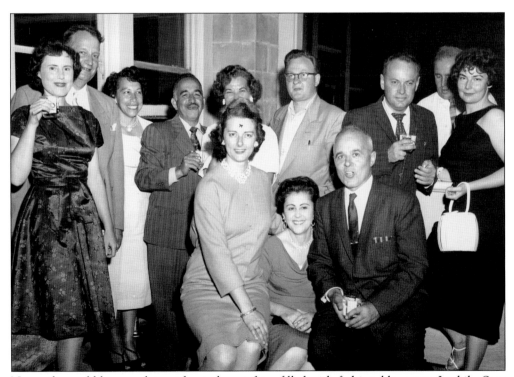

No castle would be complete without elegant fetes filled with fashionable guests. Luckily, Sam Mazza (first row, right) loved to throw parties. Mazza spoke affectionately of past festivities in a 1982 *Pacifica Tribune* interview. "We'd have great parties here," he said. "Folks would stroll out on the parapets to enjoy the view." Smiling wistfully he added, "People just don't throw parties like they used to; we'd have so much fun here." (Sam Mazza Foundation.)

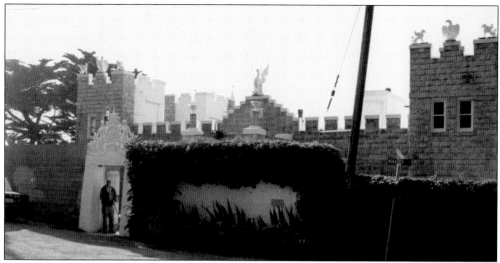

Sam Mazza loved to entertain, but first he had to turn the dilapidated property into the pristine palace seen today. "It was a real mess," Mazza said in a *Pacifica Tribune* interview. He relied on the help of his friend and groundskeeper, Ray Gracia, shown here in the doorway. By the following year, however, it was largely restored to its stately splendor and ready for esteemed guests. (Sam Mazza Foundation.)

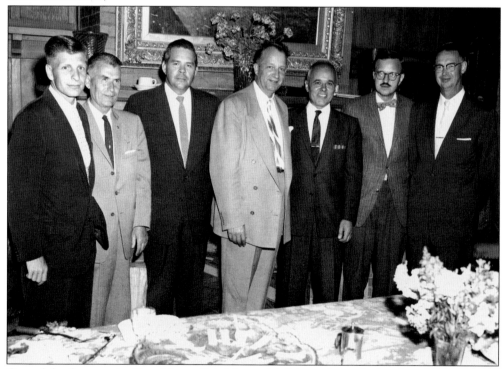

One of the first parties Sam Mazza (third from right) hosted was for his friend Raymond T. Whitney, who was running for the San Mateo County Board of Supervisors. Whitney is seen here (fourth from right) with Bill Drake of the *Pacifica Tribune* (second from right) and retired postmaster Bill Wolf (far right). That same year, Mazza hosted Whitney's daughter Joan's wedding reception, and it was standing room only. (Joan Whitney McLain.)

"It was a fairy tale night for us," recalled Joan McLain of their festive reception. "The castle was an enigma and most people had not ever been inside it, so it was very exciting for our guests." Joan and Rich celebrated their 50th wedding anniversary on November 5, 2010. (Joan Whitney McLain.)

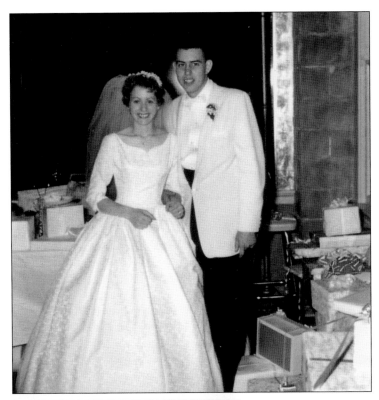

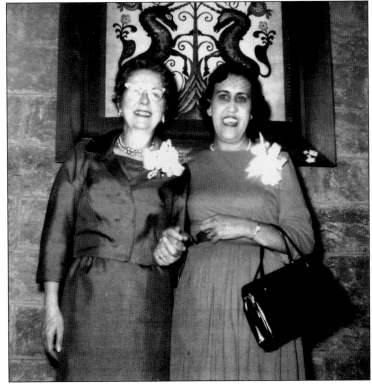

The proud mothers, Henrietta Whitney (left) and Marie McLain, were friends even before their children met and fell in love. They went shopping for the auspicious occasion together, and both opted for blue dresses for their night at the castle. Here they stand under one of Sam Mazza's fine art pieces. (Joan Whitney McLain.)

Over 300 guests turned out for the celebration and filled every corner of the castle. There were people upstairs and downstairs, even on the stairways. Joan McLain recalls there wasn't any room for dancing, even if they had wanted to. (Joan Whitney McLain.)

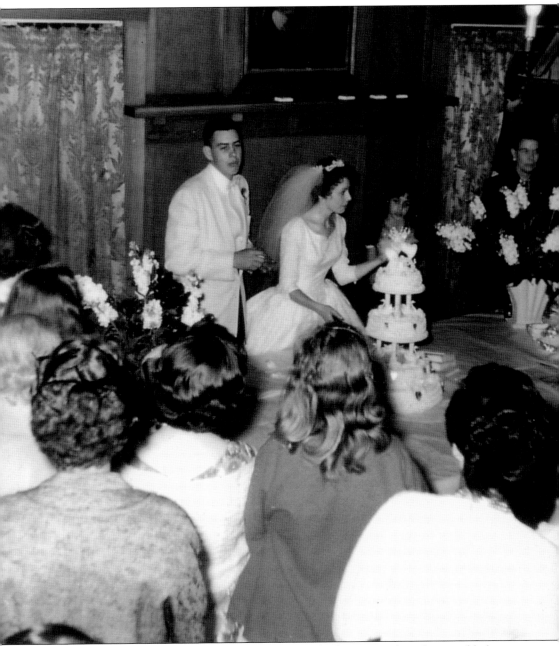

With that many people crowded into the castle, no one had to worry about being cold, despite the rainy November night. Sam Mazza was still in the process of decorating, but true to form, the décor was exquisite, with new wallpaper, gold drapes, and new carpet. (Joan Whitney McLain.)

Sam Mazza hosted many high-profile political fundraisers and parties at the castle, but perhaps the most notable was to celebrate Pete McCloskey's election to Congress in 1967. If there are ghosts in the castle, Henry was likely roaming around that night, marveling at his grandson and his son celebrating in the house he built so long ago. (Sam Mazza Foundation.)

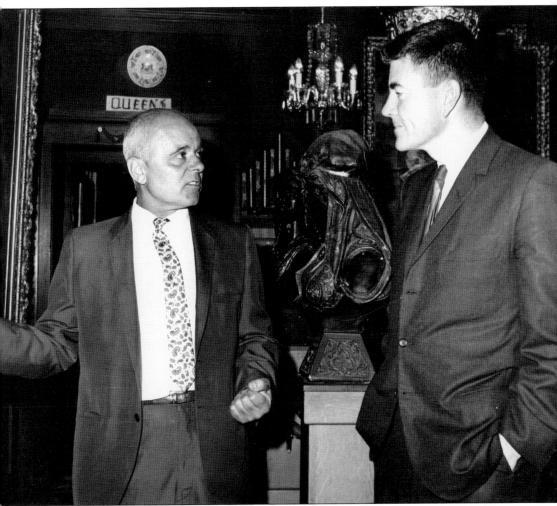

Though his congressional election party was Pete McCloskey's first visit to his father's childhood home, he became a frequent guest at the castle over the years. Here Pete (right) and Sam Mazza talk at the top of the stairs. (Sam Mazza Foundation.)

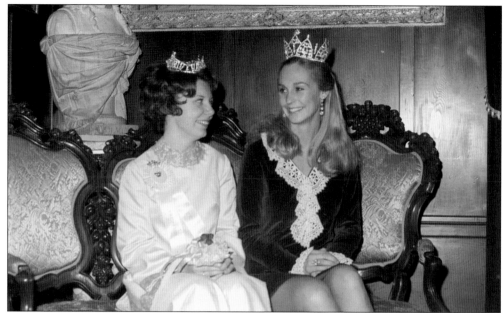

On January 13, 1971, two queens paid a visit to the castle: Miss Pacifica Donna Van Sickle (left) and Miss California Karin Kascher. Treated like true royalty, the two were escorted by police during their visits to high schools and shopping centers to sign autographs and answer questions. Decked out in tiaras, they touted the value of the scholarship awards and serving the community to 38 Miss Pacifica pageant hopefuls. (*Pacifica Tribune* photograph.)

On January 24, 1973, Sam Mazza welcomed the new pageant queens to the castle. Miss Pacifica Ann Daly (wearing crown at left), and Diane Wagner, Miss California (wearing crown at right), shared their experiences with a large group of young women vying for the crown. The royals encouraged the girls to focus on their goals and to craft a vivacious routine for the contest, which ruled out tap dancing and the Charleston. (*Pacifica Tribune* photograph.)

Sam Mazza was devoted to helping organizations with fundraisers, especially if the proceeds went to a charitable cause. He also managed to have a lot of fun in the process. Seen here, Mazza jokes around with a prospective Miss California contestant in 1978. (Sam Mazza Foundation.)

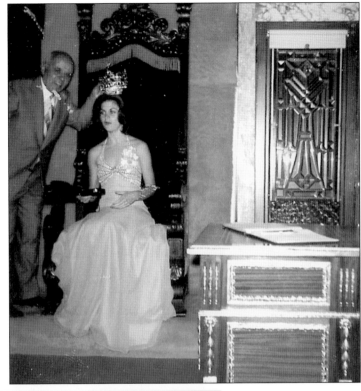

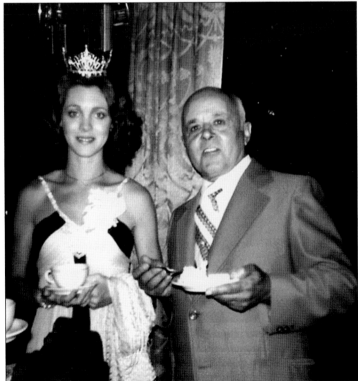

For many years, Sam Mazza provided an elegant place for young pageant hopefuls to feel like royalty for a night. Here is the king of the castle with Christine Louise Acton, who was crowned Miss California in 1978. Christine shared her experience and inspiration with several young women hoping to one day wear the Miss California crown. (Sam Mazza Foundation.)

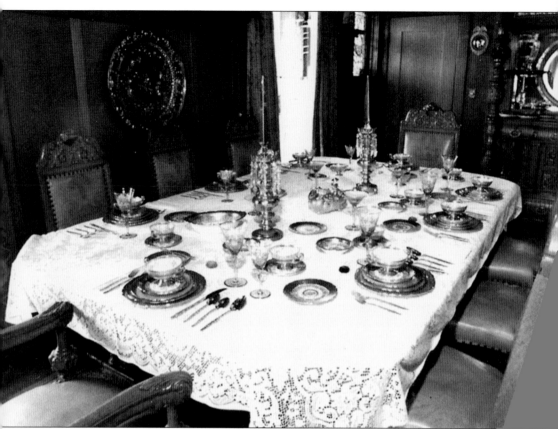

When Sam Mazza wasn't entertaining politicians and holding fundraisers, he liked to treat his friends to a high-class, multicourse dinner. "Sam was a party man," remembers Mazza's friend Ray Gracia. The castle proved an inspirational place for all who visited, culminating on the parapet with one great view. (Sam Mazza Foundation.)

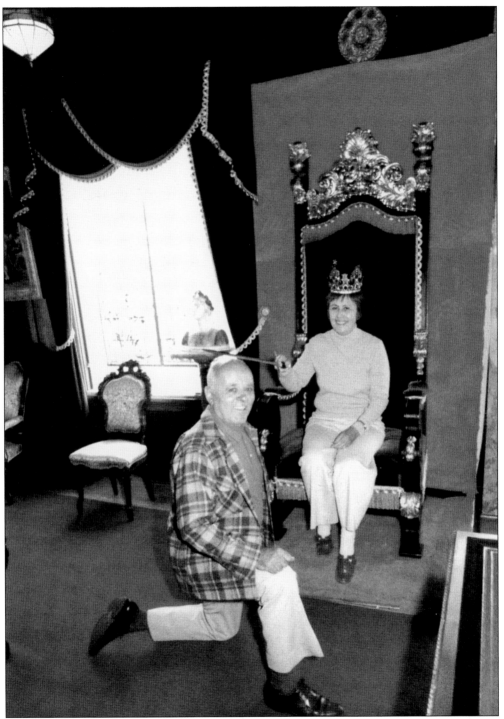

Shown here are the king and queen of the castle, Sam and Mary Mazza. Never missing a chance to play, Sam bows down before Mary at the castle throne. The throne was a theater piece adorned with gold piping, and as Sam's photograph collection suggests, the majority of his friends were treated to their moment of regal glory. (Sam Mazza Foundation.)

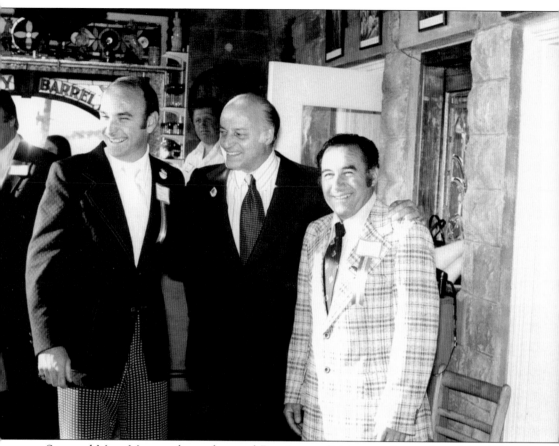

Sam and Mary Mazza welcomed several Bay Area politicians to the castle in May 1974. The champagne reception was arranged by backers for gubernatorial candidate Joe Alioto. Grouped together for this shot are Pacifica mayor Aubrey Lumley (left), San Francisco mayor Alioto (center), and Half Moon Bay mayor Mel Mello. Partygoers were asked to contribute $5 for the fundraiser and were shuttled up the steep hill in a special Alioto cable car from Eureka Square. (*Pacifica Tribune* photograph.)

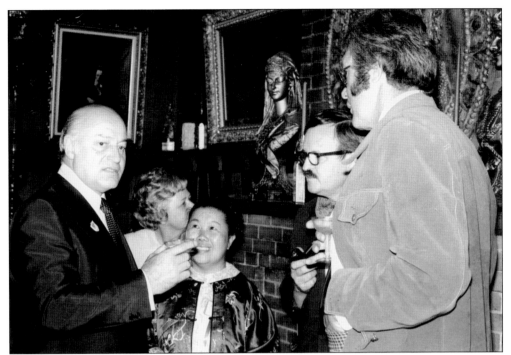

The fundraiser was the first visit by Mayor Alioto (far left) to the castle, and he enjoyed hearing about the history from (left to right) Kitty Bouly Wilson, May Gee, Bill Drake of the *Pacifica Tribune*, and San Mateo county supervisor Bob St. Clair. With more than 50 guests on hand, he had many people to meet, and he hoped to return to the castle for a more leisurely visit at some point. He told Sam and Mary Mazza, "The next party we'll have here will be a great victory celebration." (*Pacifica Tribune* photograph.)

In March 1985, the former congressman Pete McCloskey, who had retired in 1983, came to a party to share stories about his grandfather and the origins of the castle. Shown here in the castle ballroom or bar area, he talks with Gerry Schumacher (left), Sam Mazza, and Donna Starr. (*Pacifica Tribune* photograph.)

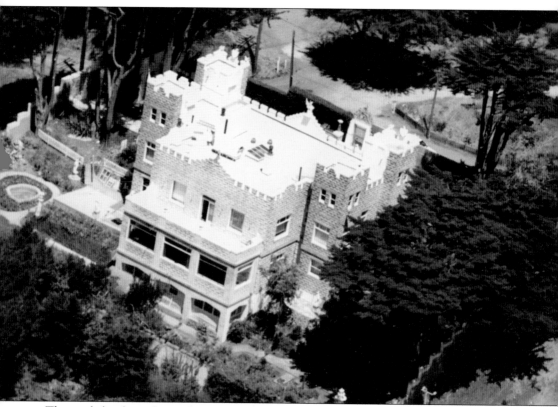

The castle has been featured in countless newspaper articles and on television programs such as *Eye on the Bay, Bay Area Backroads,* and the popular Canadian show *Weird Homes.* Sam Mazza and Doug McConnell of *Bay Area Backroads* had such a good time during the taping of the show that Mazza invited the show staff and McConnell's family to celebrate the show's wrap party there. (Sam Mazza Foundation.)

Eight

BUILDING THE CASTLE
1907–1908

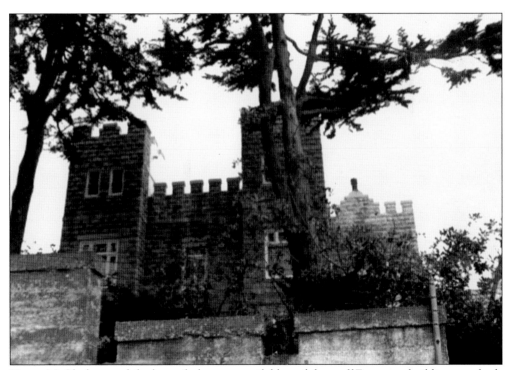

Henry McCloskey used the best of what was available and drew off European building standards that have held up for over a century. The castle at 900 Mirador Terrace was designed by San Francisco-born architect Charles McDougall and built over the course of one long year. The four-story, 24-room home reportedly cost McCloskey $100,000. (Joe O'Brien.)

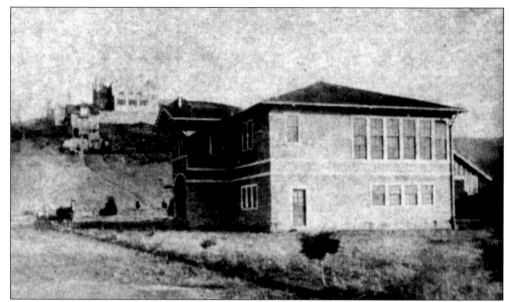

Since Salada Beach was so remote and the roads were not easy to navigate, many of the supplies arrived by ship. Sand and gravel were hauled up the steep hill by a Mr. Vornoli in horse-drawn carts, such as the one shown here. A Mr. Gervais also pitched in and hauled rock to the castle from the Rockaway Beach Quarry, which was the town's major industry. (*Pacifica Tribune* photograph.)

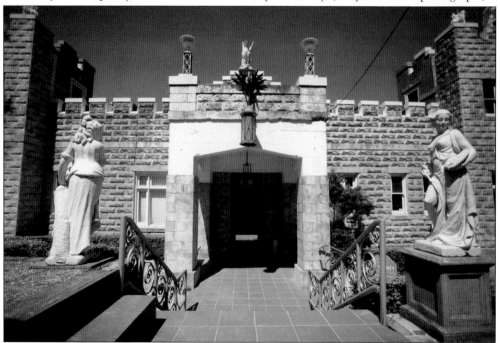

The 90-pound cement blocks were loaded on a sled and pulled up the forbidding 45-degree hill by a team of horses. The contractors used steel to reinforce the windows and corners, but it wasn't put in the blocks. As steel expands, it pulverizes the cement, and corrosion would have turned the castle to rubble. One contractor noted that they used rebar (thick, square steel bars), which was definitely way ahead of the times. (Bridget Oates.)

While restoring the turret rooms, contractors tore out the walls and uncovered a great historical castle remnant. The redwood planks are all stamped with "H.H. MC.KLOSKY, SALADA BEACH," and while they misspelled his name, the special order clearly arrived, most likely by ship. The planks are made up of old-growth redwood, and boards of these dimensions are not even available anymore. In the places where the boards are not usable, the team uses birch laminated plywood. (Both, Bridget Oates.)

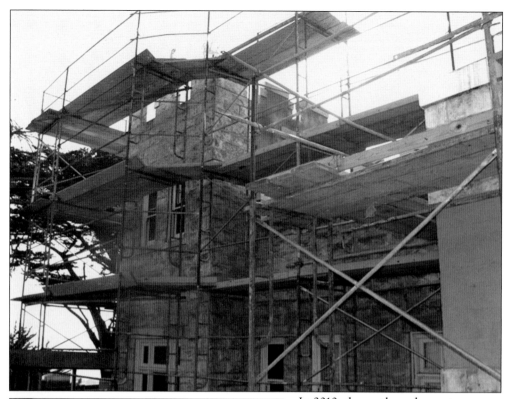

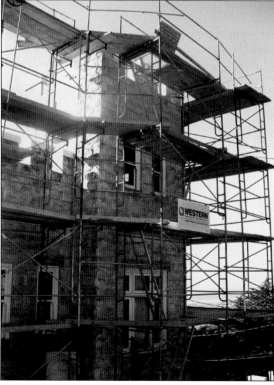

In 2010, the castle underwent an intensive waterproofing and restorative overhaul by an esteemed team from Western Waterproofing Company. The master craftsmen, who count the Cliff House on their past roster of clients, had the insurmountable task of figuring out how to fix the look of the castle while repairing the cracks and leaks. In other words, they couldn't just replace the blocks that were literally falling off the building in some areas; they had to carefully match the color of weather-beaten stones. All on the crew were impressed by how well the castle was originally constructed. The lack of rust after a century of constant exposure to saltwater and high winds was deemed phenomenal. (Both, Bridget Oates.)

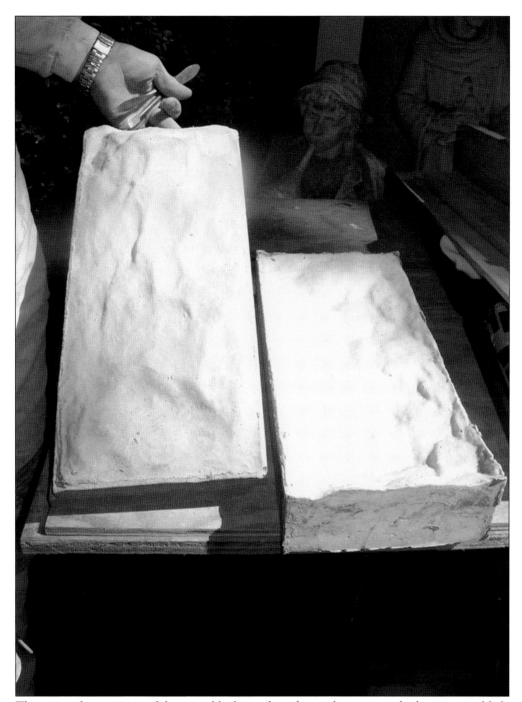

There were four patterns of the stone blocks used on the castle exterior, which were most likely cast in an iron mold. The patterned blocks on the four turrets are all 16-by-8-inch blocks, while the main house is made up of 24-by-8-inch blocks, with 8-by-8-inch and 8-by-10-inch end stones. To match the original pattern, a rubber mold of the old stone pattern was created, as shown here on the right. (Bridget Oates.)

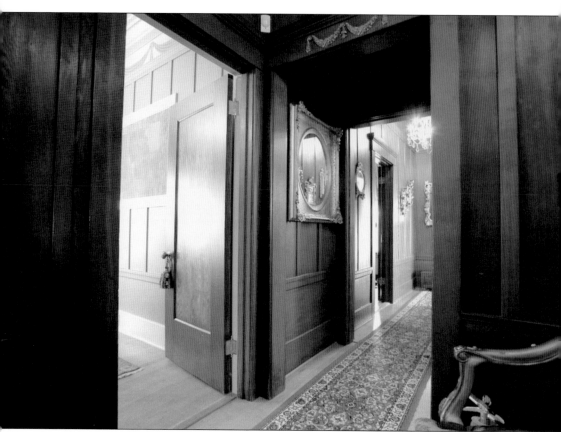

Mathius (Math) Anderson crafted all the beautiful interior woodwork, including the redwood walls (with one-inch redwood paneling), beamed redwood ceilings, hardwood maple floors, and the stairway. Round nails were used as opposed to square, cut nails, which was very unusual for the period. They were stronger and far superior to the standard nails, which also made them very expensive. (Robert Azzaro.)

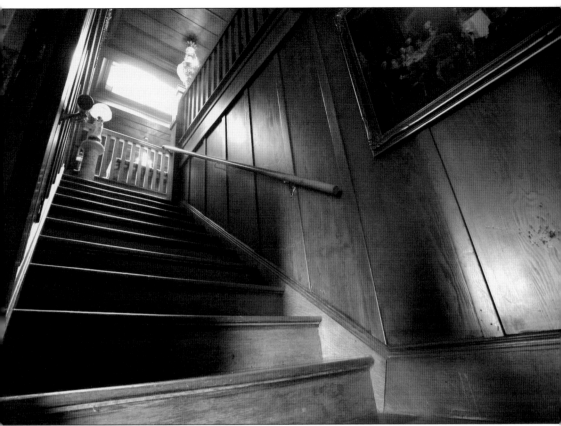

These broad oak planks have carried many colorful characters up and down the stairs, including the McCloskeys, party guests, hospital patients, high-society Chateau LaFayette patrons, rumrunners, police, and many more. The *Ghost Explorers* team put a recorder on these stairs facing the dining room and picked up two male voices greeting each other in July 2010. (Robert Azzaro.)

Math Anderson, shown here at Sam Mazza's throne in 1967, became a regular visitor to the castle and a friend to Mazza. Anderson recalled in his memoirs that when he started on the job in 1907 he worked alongside another builder, but the man left Anderson to finish the interior alone. "It took me all winter," Anderson recalled. (*Pacifica Tribune* photograph.)

Heaping more praise on Math Anderson's handiwork is the Western Waterproofing castle restoration project foreman, Monty Montgomery. He noted that only two out of 40 redwood sills in the castle have dry rot. Anderson's general store, Salada Mercantile, is now Salada Beach Café at the corner of Paloma Avenue and Oceana Boulevard. Stop by for a coffee to admire the woodwork that remains largely as it was when he built it so long ago. (Pacifica Historical Society.)

This classic knife switch electrical panel is a charming historical relic that now blends seamlessly into the white kitchen walls. One can picture the home owners shuffling into the cold kitchen, maybe with an oil lamp, and literally throwing the fuse switches to get the castle power back up and running. (Bridget Oates.)

The fact that the castle was built with electrical wiring and gas pipes was also considered unusual for the period. The electricity was all knob and tube, which is seen here. In a December 1955 article for the *Westlake Times*, Math Anderson explained that while the castle was wired for electricity and gas, it wasn't powered until much later. (Both, Bridget Oates.)

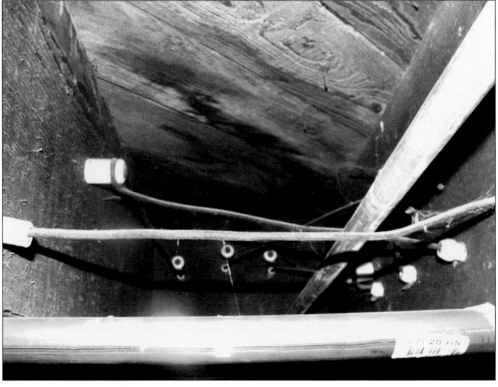

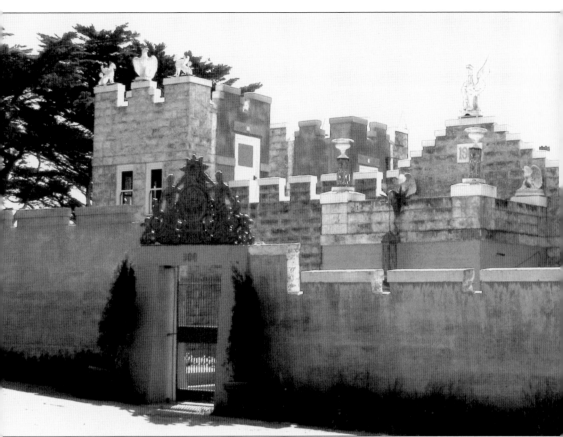

While this retaining wall is somewhat formidable, it didn't keep the police or ghost-hunting vandals from finding a way over it. Math Anderson recalled the exterior cement barrier cost around six or seven thousand dollars. "That was a lot of money in those days," Anderson said in the *Westlake Times* article. Henry McCloskey is said to have sunk deeply into debt with this venture overall. (Deb Wong.)

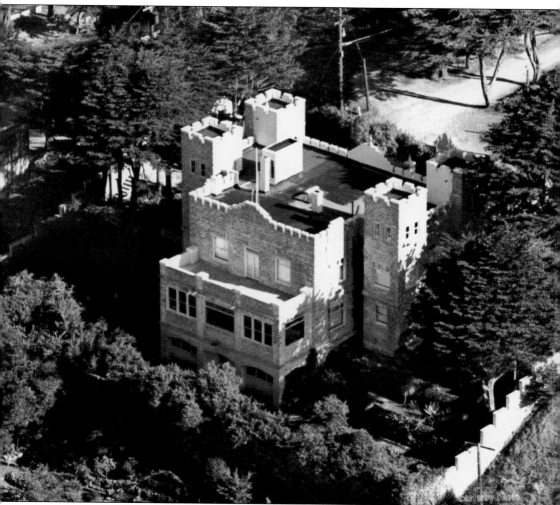

Early on, Sam Mazza had a few different ideas on what he might do with the castle. He thought about turning it into a fine restaurant or a bed and breakfast and even considered doubling the size of the lower level, but first he had to solve the parking issue. He looked into having a cable car or tram run patrons up from the bottom of hill, but with strict zoning issues, Mazza had to admit a rare defeat. (*Pacifica Tribune* photograph.)

John McLaren, famous head gardener of Golden Gate Park, was reportedly hired to landscape the original castle grounds. The esteemed landscaper installed seven terraces along the left side of the castle and filled the garden with exotic foliage. While the Eakins lived in the castle, Annie carefully tended to the grounds. She also created a lush rooftop garden and turned the bar area into a solarium that was well stocked with ferns and flowering plants. (Sam Mazza Foundation.)

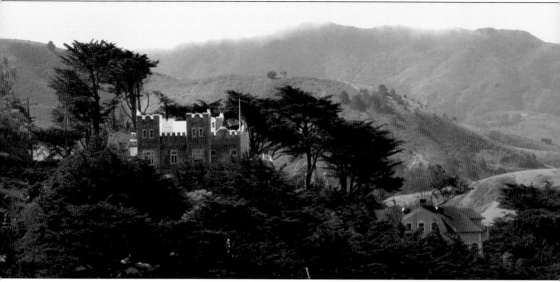

In stark contrast to its original barren surroundings, the castle is now nestled in the trees with its most loyal companion, Pacifica fog. The calamitous years have seceded, and it is likely the police will never again scale the outer wall or batter down the door. The castle will not change hands again or fall into disrepair; it will remain a charming reminder of Pacifica's spirited past and the power of holding on to dreams. Sam Mazza was said to be very proud of the fact that he and his Sicilian family struggled through the Depression and triumphed with tenacity and hard work. He hoped that the successes in his life would inspire others to realize their dreams as well. (Michael A. Wong.)

From the toilet floats to the white elephant flag, Sam Mazza had a lot of fun with the castle, and it was his wish that people would continue to enjoy it. Thanks to the Sam Mazza Foundation, the castle will lend ongoing support to charitable organizations to help people make their dreams come true, as Mazza would have wanted. There will also be occasional tours, so visitors can feast their eyes on his museum-like collection and let their minds wander back in time, marveling at all the amazing things that transpired at the majestic castle on the hill. For his generosity, his playful spirit, and his devotion to maintaining this treasured Pacifica landmark, cheers to you, Sam Mazza! (Sam Mazza Foundation.)

www.arcadiapublishing.com

Find Your Place in History.